ANTRIM COAST

Industrial Heritage

Fred Hamond

DEPARTMENT OF THE ENVIRONMENT (NI)
ENVIRONMENT SERVICE

ANTRIM COAST & GLENS

Industrial Heritage

Fred Hamond

BELFAST: HMSO

**Countryside and Wildlife
Interpretation Series**

The series of booklets has been commissioned by
the Department of the Environment (NI)
Countryside and Wildlife Branch to provide
background information about the Northern
Ireland countryside; its landscapes, wildlife and heritage.

The views and opinions expressed in this booklet
are entirely those of the author and do
not necessarily conform with those of the Department.

Department of the Environment (NI)
Environment Service
Countryside and Wildlife Branch
Calvert House
23 Castle Place
BELFAST
BT1 1FY

Front cover: Blackcave Tunnel, southern gateway to the Antrim Coast & Glens AONB

CONTENTS

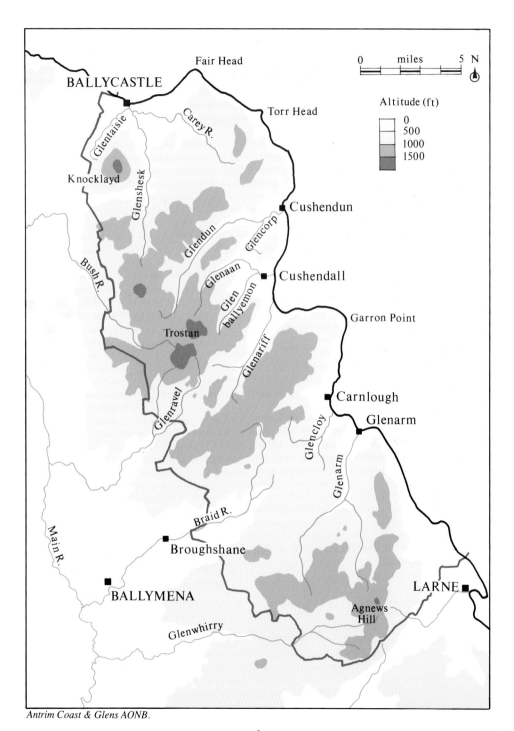

Fair Head

BALLYCASTLE

Torr Head

Carey R.

Glentaisie

Knocklayd

Glenshesk

Cushendun

Glendun

Glencorp

Bush R.

Glenaan

Cushendall

Glen ballyemon

Garron Point

Trostan

Glenariff

Glenravel

Carnlough

Glenarm

Glencloy

Glenarm

Main R.

Braid R.

Broughshane

BALLYMENA

LARNE

Agnews Hill

Glenwhirry

0 miles 5 N

Altitude (ft)

0
500
1000
1500

Antrim Coast & Glens AONB.

FOREWORD

It is a paradox that one of the most interesting facets of an 'Area of Outstanding Natural Beauty' is its industrial history and remains thereof. 'Natural' is not the first epithet to come to mind in describing mills, quarries, mines and bridges.

There are no parts of Ireland where the landscape is untouched by the hand of man. Even our most beautiful areas – the plateau, glens and coast of County Antrim fully merit status as one of these – have been fashioned by the activities of our ancestors. But neither man nor nature alone can claim all the credit. It has been the interplay between the two which has created the landscape we now treasure so highly.

To understand and appreciate the landscape we have inherited, it is essential to look into the past. It was many millions of years ago that volcanic activity produced the broad expanse of basalt which underlies most of the plateau. More recently, but still tens of thousands of years ago, the movements of great glaciers during the ice ages sculptured the great U-shaped glens. After the last retreat of the ice, vegetation gradually recolonised the land surface.

The finer details found today in the patterns of vegetation and the land surface are largely the outcome of man's activities in exploiting the natural resources of the area – farming, mining, manufacturing, building, transport, forestry, etc. Many of the small-scale industrial activities in the area have long since closed down, but signs of them live on in a diversity of structures now derelict or adapted to new uses. In chronicling its industrial archaeology in such an authoritative fashion, Fred Hamond has made a major contribution to the appreciation of this special corner of our country, and I am delighted that we have the opportunity to publish his work in our Interpretation Series.

Dr John Faulkner
Director of Conservation, Environment Service
Department of the Environment (NI)

ACKNOWLEDGEMENTS

Many people have assisted me in the preparation this book, particularly Andrew Stott of the Countryside and Wildlife Branch of the Department of the Environment for Northern Ireland who was involved in all aspects of the project, from initial research and field survey, to proof reading of the final text. I am also indebted to the many landowners who allowed me access to their land during the course of my fieldwork. I should also like to acknowledge the indirect contribution of the authors of the many published articles on aspects of the area's industrial heritage.

Thanks are also due to Anne Given and Michael Coulter of the Archaeological Survey for access to their Industrial Archaeological Record. Also to the staff of the Geological Survey of Northern Ireland, and Martyn Anglesea of the Ulster Museum for facilitating my research.

I am indebted to a number of people for answering specific queries: Mike Baillie, Bret Cunningham, Fiona Flanagan, Ian Hamilton, Barry Hartwell, Frances Hazel, Jean Ludlow, J.C.K. McDowell, and Bob McKay.

Special thanks are due to those who kindly read and commented upon earlier chapter drafts: Francis Cox, Bill Crawford, Cahal Dallat, Charles Friel, Charles Ludlow, Henry Lyons, Denis Mayne, Kevin O'Hagan, and Jack Preston.

I am grateful to Frank Cox, Kevin O'Hagan, Linda McCullough, Tom McDonald and Jack Scally for the loan of photographs. Permission to reproduce photographs was kindly granted by the Archaeological Survey, Belfast Telegraph, Irish Linen Guild, National Library of Ireland, Northern Ireland Tourist Board, Presbyterian Historical Society, Ulster Folk and Transport Museum and Ulster Museum. Maps are based on, and reproduced from, Ordnance Survey maps with the sanction of the Controller of H.M. Stationery Officer and are crown copyright reserved (permit no. 453).

Finally, my thanks to John Straghan of HMSO for his advice on preparing the text for publication, and to Daphne Farnham for proof reading. Any mistakes, omissions or misinterpretations are, however, my own responsibility.

PREFACE

Industrial Archaeology concerns itself with a wide variety of past industries such as mining and quarrying, milling, the provision of power and water, roads, bridges, railways and water transport.

The topic is relatively undeveloped in Northern Ireland, with only a few general publications to its name, notably Rodney Green's *Industrial Archaeology of Co.Down* (1963), and Alan McCutcheon's *Industrial Archaeology of Northern Ireland* (1980). As yet, however, there has been no in-depth study of the industrial heritage of a particular region.

This book focuses on one such area, namely the Antrim Coast and Glens Area of Outstanding Natural Beauty (AONB). The AONB was designated by the Department of the Environment for Northern Ireland in 1988 and as part of an ongoing programme of research and publication, the Countryside and Wildlife Branch commissioned the author to identify and survey all industrial archaeological sites lying within its boundaries.

Most people will probably be aware of the pre-eminence of Belfast in linen, tobacco, shipping and engineering. However, the material presented here is perhaps more typical of Irish industry as a whole – small scale and rural in nature, and focused on the seasonal agricultural cycle.

The book is mainly concerned with 19th century industry and is broadly organized by extractive, manufacturing and service industries, and communications. Each chapter presents an overview of those particular sites within the AONB, the more interesting of which are detailed in the gazetteer. The book concludes with a listing of all industrial sites known to the author.

Superscript numbers within the text refer to sources listed at the end of each chapter. Highlighted numbers in brackets refer to particular sites in the gazetteer. Photograph credits are as follows: AS – Archaeological Survey, NITB – Northern Ireland Tourist Board, NLI – National Library of Ireland, UFTM – Ulster Folk and Transport Museum, UM – Ulster Museum. Unless otherwise stated all other photographs are by the Countryside and Wildlife Branch, and the author.

Awareness of these sites derives largely from the first four editions of the Ordnance Survey 6" (1:10,560) maps of the 1830s, 1850s, 1900s and 1920s. These were supplemented with documentary material, notably the *Ordnance Survey Memoirs*, published in the 1830s, and *The Glynns*, the Journal of the Glens of Antrim Historical Society. All sites were visited by the author over the winter of 1989-90.

Rathlin Island, although in the AONB, is to be the subject of another publication in the same series and is thus not included here.

This book attempts little more than a broad canvas of past industrial activity in the region. Hopefully it will be a useful starting point for interested researchers to flesh out the picture and sketch in the people involved.

Fred Hamond
November 1991

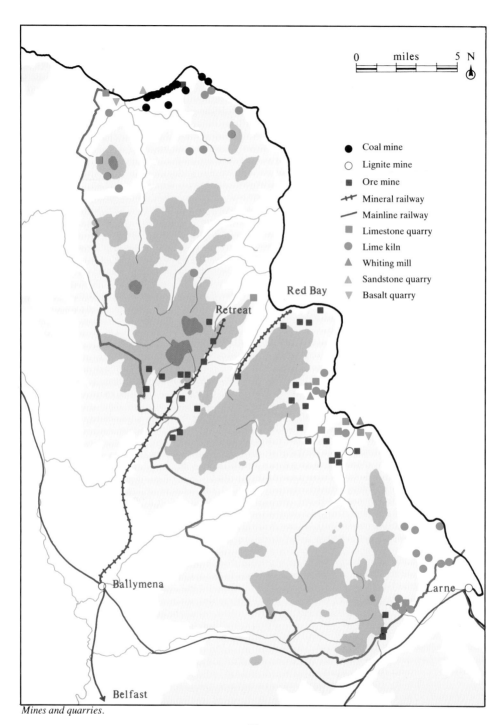

Mines and quarries.

1

MINES AND QUARRIES

The diverse geology of North-East Antrim has lent itself to extensive mining and quarrying. Some 5000 years ago, the volcanic plug of Tievebulliagh (west of Cushendall) was being quarried for porcellanite, from which stone axes were fabricated for distribution throughout the British Isles.

In the more recent past, coal has been mined at Ballycastle since the 1600s. In the later 1800s, iron ore and bauxite (aluminium ore) were extensively mined on the Antrim Plateau, particularly around Cargan.

During the 1800s and earlier 1900s, many basalt and limestone quarries were opened up for building stone and road ballast, besides countless sand and gravel pits. Numerous lime kilns were also erected for the conversion of limestone into agricultural fertilizer and mortar.

1.1 Coal and Lignite Mines

The economic importance of coal cannot be understated, fuelling as it did Britain's 18th century industrial revolution. In Ireland, however, viable reserves are restricted to small areas, principally in Counties Kilkenny (Castlecomer), Tyrone (Coalisland), and Roscommon (Arigna); within the Glens, coal measures are also found immediately east of Ballycastle and at Murlough Bay. Small pockets of lignite ('brown coal') also occur sporadically, although never of any great economic significance.

Ballycastle Collieries

The geology of much of Co.Antrim, the North-East included, comprises Cretaceous Chalk overlain by Tertiary Basalt. However, around Ballycastle, Carboniferous sandstones, shales and limestone also occur, laid down some 300 million years ago. Within these strata a series of coal measures outcrop for some two miles along the coast between Ballycastle and Fair Head.[1]

The strata dip from east to west, the seams varying in thickness from several inches to 4ft at the 'Main Coal'. Their continuity is interupted by a series of vertical faults which divide the strata into individual sections, each mined as a separate colliery. The coal itself varies from rather poor quality slack to high grade bituminous lump.

Near horizontal tunnels (levels or adits) followed the seams in from the coast. Their southern extent was limited to about 800 yds by the 'Great Gaw' Fault, which runs west-east from Bath Lodge at the eastern end of Ballycastle Bay, via Crockateemore, to Murlough Bay. This has caused strata to the north to be downthrown relative to those to the south. There is thus a severe discontinuity in the coal seams, adits driven in from the north coming to an abrupt end. Seams to the south of the fault could only be exploited by the more expensive method of sinking vertical shafts. Thus, whereas seams along the coast have been mined since the 1600s, it was not until around 1900 that the inland measures were systematically worked.[2]

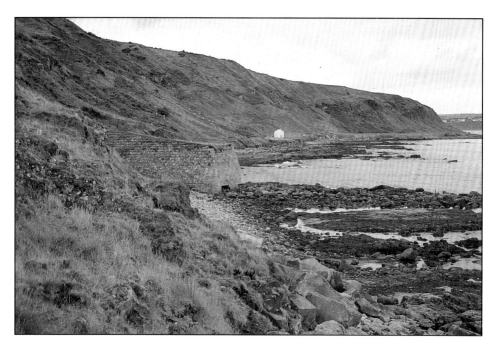

Coastline in vicinity of Ballycastle coal mines. The remains of Ballyvoy Pier are at centre left.

The earliest reference to coal mining in the Ballycastle district is in the 1629 will of the first Earl of Antrim. The coal would probably have been used locally in the home, to heat salt pans, and to burn lime. It was to be another hundred years before its commercial potential began to be more fully realized.

In 1717 the Irish Parliament offered a prize of £1000 for anyone who could deliver 500 tons of Irish coal to Dublin, until then dependent on expensive English and Scottish coals.[3] In response to this challenge, two Dublin merchants, Richard and William McGuire, obtained the coal mining rights to the Ballycastle–Fair Head district from the Earl of Antrim in 1720. By the following year they had secured the £1000, with more to follow. However, their enterprise appears to have fizzled out by the early 1730s.

Fortunately the manager of the collieries, one Hugh Boyd, recognized the mines' true worth. In 1736 he re-negotiated and was granted the rights

to the area. Seeing the need for proper facilities from which to ship the coal more efficiently, he successfully petitioned the Irish Parliament for grants to erect a harbour and pier (chapter 4). Although less satisfactory, the numerous small volcanic dykes running out to sea also provided makeshift jetties from which coal could be loaded into small boats for transfer to larger vessels lying offshore.

Boyd opened up new mines and extended the workings in existing mines. A tramway facilitated the easy conveyance of the coal directly to the harbour. During the collieries' zenith in the 1750s, over a hundred miners were at work, producing 5000-8000 tons of coal annually. Besides export, Boyd also stimulated local demand by setting up a number of coal-based industries in Ballycastle, including a glass works and soap works (chapter 4).

Unlike many other mines, noxious and inflammable gases were not a problem. However, as tunnelling progressed, so flooding became an increasing concern, particularly at the Salt Pans Mine at the west end of the coalfield where the

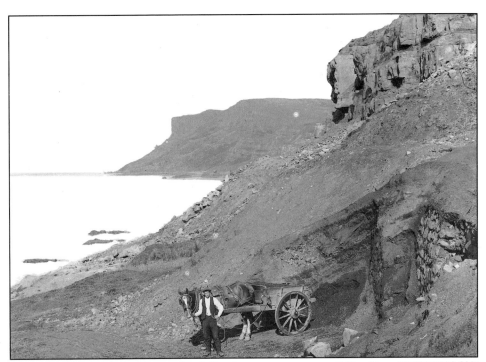

Gobb colliery. (UFTM: WAG 831)

exposed strata were just above sea level. Boyd installed a water-powered pump, the water being channelled to the wheel along a one mile long lade (headrace) from the Carey River, the course of which can still be partly traced.

With the gradual exhaustion of the Main Coal, and need to work thinner and often discontinuous seams deeper into the hillside, mining costs increased whilst production declined. Boyd's death in 1765 finally brought the 'golden era' of the Ballycastle Coalfield to an end.

Mining nevertheless continued, albeit on a smaller scale. John Dubourdieu, writing in 1812, gives a particularly detailed account of the mines.[4] He notes the levels as being about 4ft wide by 4½ft high, gunpowder being used in their progressing. A three-man team, comprising a cutter, bearer, and trammer, could produce upwards of a ton of coal per day. They were paid on a piece-rate basis by the mine leasee, and expected to supply their own candles and tools.

Dubourdieu noted the miners, then numbering around 100, to be: 'rather a lazy and indolent denomination of people; they work only from six to eight hours in the day time, and, when they calculate that they have earned from one shilling to 18 pence for their day, they are satisfied, and retire to idleness or amusement'.

Apart from the Ballycastle hinterland, the principal outlet for the coal was Coleraine. By the 1830s, however, it was only marginally cheaper than imported Scottish coal and most was consumed locally.[5]

Over a dozen collieries are known to have operated at one time or another along the coast between Ballycastle and Fair Head: Salt Pans, White Mine, Falbane, Doon, North Star, West Mine, Lagglass, Goldnamuck, Pollard, Griffin, Gobb, Portnagree, Carrickmore (West and East), and Portnaloub.

The heyday of the mines was in the decades around 1750 and most had been worked out by the mid-1800s. Only a few continued to function thereafter, including the White Mine which was

Ballyreagh colliery, early 1900s. Note 'Belfast Coal and Iron' on chimney and fireclay kilns at left. (F. Cox)

reopened during the Second World War. The coal was sold locally for domestic use, and part-time mining continued until the late 1950s.

Few traces of the mines are now evident, save the occasional spoil heap along the rough track towards Fair Head. Recurring landslips have concealed most adit entrances, and only two are now in evidence – at White Mine (**12a**), and North Star Colliery (**12b**).

Murlough Bay Collieries

Coal also outcrops on the east side of Fair Head, above Murlough Bay. However, extensive land slippage hindered its ready exploitation, and the exposed shoreline made dispatch difficult. Thus, although mining took place sporadically from the later 1700s to 1940s, it was not on the same scale as at Ballycastle.

High up on the slope, at the foot of a dolerite cliff, an open adit (now flooded) can still be found (**15a**). Further along the coastal track, the double entrances to the Arched Mine (**15b**) are clearly evident. Nearby are the ruinous remains of mine workers' houses (**15c**).

Inland Collieries

In the early 1800s, abortive attempts were made to deep-mine coal south of the Great Gaw fault. In 1905, the North Antrim Mining Syndicate opened a shaft mine at Ballyreagh near Ballyvoy. Their successors, the Belfast Coal and Iron Syndicate, worked the coals for several years, and also established a pottery, pipe and tile works to avail of the local fireclay associated with the seams. Production was short lived, however, ceasing in 1908. More successful was a mine at Craigfad, worked from the 1920s until the mid-1960s. Little trace of either mine now survives.

Lignite

Brief mention has already been made of the basalt rock which overlies the chalk. Within it are so-called Interbasaltic Beds, which mark weathered land surfaces on which vegetation developed. Once submerged in lava, the organic matter converted in some instances to lignite.

Although worked extensively in the vicinity of Ballintoy, no large-scale lignite mining appears to have taken place within the AONB save for a later 18th/early 19th century working at Libbert, south of Glenarm, nothing of which survives.[6]

1.2 Iron Ore and Bauxite Mines

In use for over 2000 years, iron is the world's most widely ulitized metal. Nowadays, it is usually alloyed with carbon to form steel; in the past, however, cast- and wrought-iron were commoner forms. In nature, iron usually occurs as iron oxide, and smelting with coke and limestone is necessary to recover it.

Small-scale iron works operated in Co.Antrim during the 17th and 18th centuries, relying on imported iron ore and pig iron for their raw material. From the mid-1800s, native iron ore began to be systematically mined around Ballycastle. In the 1860s, activity shifted to Mid-Antrim, and the upper Glenravel Valley in particular. During the 1870s and '80s, this area became Ireland's biggest iron ore producer. No smelting was done locally, however, the ore being shipped to Britain.[7]

Aluminium ore is also found associated with the iron ore, and it was mined in Co.Antrim from the 1880s until the 1940s. Aluminium has the advantage over iron in being both light and non-rusting. Again, most of the ore was shipped to Britain for processing.

Over 400 separate workings (adits and trial pits) are known in Co.Antrim, over half of which lie within the boundary of the AONB.[8]

Ballycastle Ironstone

As well as coal, the Carboniferous rocks around Ballycastle also contain thin seams of iron-rich ore, particularly in the vicinity of Carrickmore, to the west of Fair Head. These seams, known as 'blackband ironstone', comprise a mix of iron carbonate (siderite), clay and coal-like material.

Once extracted, whether by open-cast, adit or shaft working, the ore was calcined by burning off the coaly material, so converting the iron carbonate to iron oxide. This was then shipped to Scotland for processing into pig-iron. Each ton of ironstone yielded around 5cwt of iron.

The Carrickmore Mines were worked intermittently from the mid-1850s until 1880, primarily by the Ballycastle Iron Mining Company.

Production peaked at 30,000 tons in 1872, decline coinciding with the expansion of the Mid-Antrim iron ore mines (see below).

Although no adits are now apparent, terraces of spoil from mining and calcining are still visible along the shoreline **(13a)**. Nearby are the remains of Carrickmore Jetty **(13b)** and Ballyvoy Pier **(13c)**, from which the ore was exported. To the south is Collier's Row **(14)**, built by the Company in the 1860s to house miners (and, judging by its name, also used by coal miners).

The Interbasaltic Ores of Mid-Antrim

Iron- and aluminium ore occur in the Interbasaltic Beds between the Upper and Lower Basalts which covered much of the county some 60 million years ago. These beds were formed by weathering of the upper horizons of the Lower Basalt to form a speckled reddish-purple 'lithomarge', rich

Carrickmore ironstone mine:
spoil and calcining terraces.

15

Ore mining in the Glenravel Valley.

16

in aluminium, iron and silica. Further weathering caused chemical movement within this margin, a process known as 'laterisation'. Iron migrated upwards, forming iron-rich laterite, that especially rich in iron being known as 'iron ore'. Aluminium-rich laterite formed lower down, and is termed 'bauxite' where it has a high aluminium content. Iron ore is reddish in colour, whereas bauxite is usually grey or brown.[9]

Mining in the Glenravel Valley

Slievenanee Mountain, above Cargan, was the focus of early mining activity. Its name derives from the Irish meaning 'Iron Mountain', suggesting a long-held awareness of the area's ore-bearing potential. However it was not until the early 1840s that efforts were made to instigate commercial exploitation.

Rock samples analysed by Nicholas Crommelin, the local landlord, were found to have an iron content of almost 20%. This encouraged him to set up a peat-fired smelter (**36k**) on the banks of the Skerry Water below his newly-founded settlement of Newtown Crommelin. Unfortunately his endeavours proved fruitless as the ore was of poor quality, and the firing temperatures too low. The resultant slag was impossible to work into usable iron, and so the experiment was abandoned. The furnace still stands to this day, a monument to the beginnings of the Mid-Antrim iron ore industry.

Attention then switched to the Templepatrick area, where iron ore beds were uncovered during the cutting of the Belfast-Ballymena railway in the late 1840s. Systematic mining began in the early 1860s, the ore being dispatched to Britain. However, as it was not particularly rich in iron, it was used as a flux in the smelting of higher grade material from elsewhere.

Activity re-focused on the Mid-Antrim area when, in 1866, James Fisher, a Barrow-in-Furness ship owner with experience of the iron industry, took up residence at Cleggan Lodge, five miles north-east of Broughshane. His attention was drawn by the parish priest, William Macauley, to the Interbasaltic Beds at Ballynahavla, north-east of Cargan. Macauley's intention was to stimulate employment, the local domestic linen industry then being in decline (chapter 3). Fortunately, Edward Benn, the local landlord, was also aware of the ore's value, and so it was that Benn granted Fisher a licence to mine.

This Fisher commenced, first as open-cast working along the southern scarp of Slievenanee, to the west of Ballynahavla Bridge, then as a series of adits into the hillside. In the first six months of operation, almost 20,000 tons of ore were mined. A horse-drawn tramway conveyed the ore waggons to the roadside at Parkmore for haulage by horse-and-cart to Red Bay for shipment to Britain. However, although having upwards of 60% iron, the ore contained many impurities such as phosphorus, aluminium and titanium. As with the Templepatrick ores, it was therefore not smelted alone, but incorporated as a flux in the smelting of higher grade ores.

Reddish-purple lithomarge within the Interbasaltic Bed.

17

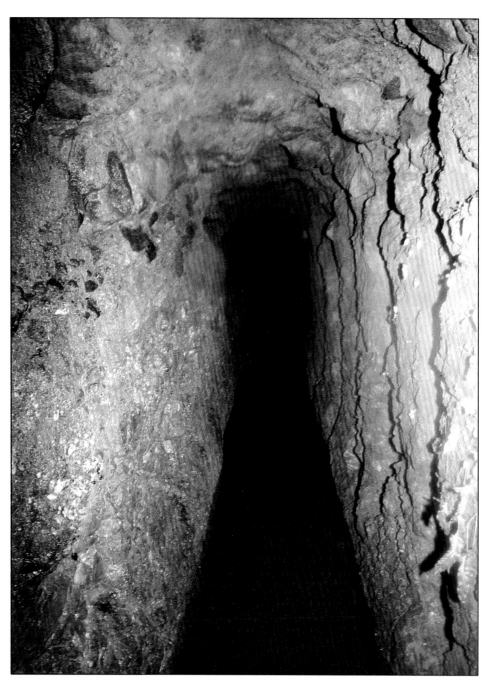

Main access shaft, Dungonnell ore mine.

In spite of their distance from the British markets, and somewhat indifferent quality, the Mid-Antrim ores had the advantages of being relatively inexpensive to mine compared with British ores. Initially, much could be abstracted by open-cast methods, but as these deposits ran out tunnelling became necessary. Fortunately the run of the seams allowed working along self-draining horizontal adits, whilst the uniform basalt overlay minimized the need for expensive support timbering. The principal adits were made wide enough to accommodate the hutches into which the ore was loaded from the many smaller side workings. Capital outlay was also minimal, the basic tools being picks, shovels and barrows.[10]

Following Fisher's success, other companies began mining in the 1870s and '80s: the Antrim Iron Ore Company at Cargan, Dungonnell; Tuftarney and Trostan; the Parkmore Iron Ore Co. at Parkmore and Essathohan, the Evishacrow Iron Ore Co. at Evishacrow, and the Crommelin Mining Co. at Skerry East. Many also extended south-west along the Glenravel Water to Mountcashel and Rathkenny, and into the Braid Valley to Elginny and Ballylig.[11]

By the early 1870s, some 700 miners were at work in the Glenravel district, mostly ex-labourers and small tenant farmers anxious to supplement their meagre income. The village of Cargan (originally called Fishertown) owes its development to this period, with the construction of mine workers' houses, some of which survive, albeit greatly refurbished; those at Parkmore, further up the road, are now gone.

Ore production rose dramatically in the 1870s, peaking at 228,000 tons in 1880. Thereafter it declined markedly, only 100,000 tons being mined four years later. The reasons behind this fall are several. On the one hand, demand from Britain was falling, as was the price of ore. On the other, the most readily accessible deposits, particularly the high-grade pea-like 'pisolitic' ores, were becoming worked out. Averaging 1–2ft in thickness, a cubic yard of rock contained one ton of ore which could yield upwards of 50–60% iron. Below this was lower-grade 'pavement' ore, some 5ft thick, but with only 20–30% iron.

It was in order to find other rich, easily worked, deposits that numerous exploratory trials were made elsewhere in the Interbasaltic Beds around the plateau edge, and along the North Coast.[12] Attention also turned to the aluminium-rich ores, and bauxite mining (see below).

Besides the diminishing iron content of the extractable ore, later workings also met with unfavourable dips in the strata which caused flooding. The relatively high cost of transportation to Britain was also a recurring theme in the industry's demise. These factors all combined to make the Antrim ore uncompetitive in relation to cheaper, higher-grade foreign ores.

James Fisher & Sons' Glenravel mines eventually closed in 1913. By the 1920s, only the Antrim Iron Ore and Crommelin Mining Companies remained in operation. By now, however, bauxite was to the fore, the last iron ore proper being mined in the mid-1920s.

It is today difficult to envisage the many miles of underground passage which honeycomb the hillside. Most adit entrances are now blocked, and are marked only by shallow grassy depressions. Evidence of past mining activity can be seen around Cargan, particularly at the Glenravel Mines (36e) where open-cast workings and terraced spoil heaps are clearly visible along the scarp. Quarrying of the spoil for road ballast has uncovered several adits, now blocked for safety.

Immediately west, along the Skerry Water, are the spoil heaps associated with the various tracts worked by the Crommelin Mining Company from the 1880s onwards: Tuftarney, Crommelin, Walker's Drift, Salmon's Drift, Spittal's Drift, and Herd's Drift (36f).

On the southern flanks of Binvore Hill, terraced spoil heaps associated with the Evishacrow Mines (36d) are evident above the Cargan Water, along with a good exposure of red iron ore and grey bauxite. No traces survive, however, of the workings on Tuftarney Hill just west of Cargan.

Just west of the Evishacrow Mine is the now-ruinous Binvore Cottage (36j). An inscribed stone commemorates its erection by Edward Benn, the local landlord, in 1836. Benn moved to Glenravel House, just south of Cargan, in 1842.

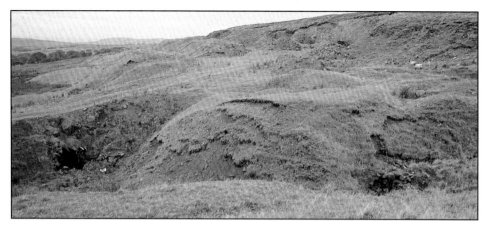

Glenravel mine: extensive open-cast workings and spoil heaps are clearly evident. An old adit is revealed in the face of the quarry, centre right. The former Parkmore mineral railway crosses the stream at bottom left, and contours around the slope.

East of Cargan the prominent spoil heaps of the Cargan Mine (**36h**) are still visible, as are those of the Dungonnell Mines (**36i**) further up the Ballsallagh Valley.

Further north-east, at the extensive Essathohan and Parkmore Mines (**36b,c**), substantial spoil heaps are obscured by the forest beside the main road. North-east again, around the eastern flanks of Trostan, further spoil heaps and adits are also traceable (**36a**).

Mineral Railways

As the ore was destined for British smelters, the situation of the Cargan mines, less than 10 miles from Red Bay Pier, would seem to have been highly advantageous. However, the fact that they were also over 1000ft above sea level meant that the ore had to be moved down the steep gradients of Glenballyemon.

Initially the Ballymena-Cushendall road provided the main access to the sea. In the later 1860s, James Fisher laid down a two mile tramway to link his Glenravel Mines with the road at Parkmore. A further tramway connected the Trostan Mines with the road. The ore was then drawn to Red Bay Pier by horse.

Given the bulk and weight of the ore, it was no easy matter to shift. In the early 1870s, some 600 horses were apparently engaged in this task. Their upkeep – feeding, grooming, and tackle repair – would have been a major undertaking. Not surprisingly therefore, haulage costs were high. In the early 1870s for example, ore from the Evishacrow Mines fetched 11s6d per ton at Red Bay. Actual production costs amounted to 7s6d, of which 3s4d was for haulage – ie 45% of costs. With the steady decline in the market price of ore which occurred in the 1870s, it therefore became imperative to reduce the relatively high cost of transportation.

The first attempt to mechanize the carriage of ore, and so reduce costs, was made by the Antrim Wire Tramway Company. In 1872 they erected an aerial ropeway around the northern slopes of Lurigethan to link the Glenravel, Evishacrow and Cargan mines directly with Red Bay Pier. The cable was apparently driven by steam engines at Knockans and Evishacrow, and capable of conveying some 200 tons of ore per day. However, its use was short-lived, the line being sabotaged in 1873. Although no one was ever charged, hauliers were suspected, as many would have become unemployed had the line succeeded. The link was never reinstated, and all traces were removed in 1881.[13]

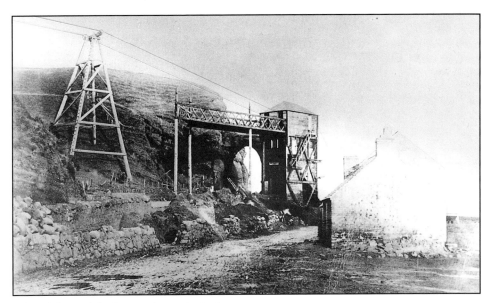

As mining activity became increasingly frantic in the 1870s, the need for improved transport became ever more acute. The obvious solution was a railway, and with this in mind the Ballymena, Cushendall & Red Bay Railway Company was formed in 1872. As its grandiose name implies, the intention was to run a line from Ballymena to Cargan, over the slopes of Slievenanee to Cushendall, and so to Red Bay Pier.[14]

By 1875 the line had reached Cargan, extending to Retreat in 1876, a total distance of 16½ miles. It was built at a gauge of 3ft, in contrast to the 5ft 3in standard-gauge, the former being cheaper to lay and maintain, and also more suited to the tighter curves and steeper gradients of the upland terrain.

In spite of this choice of gauge, the steep slopes of Glenballyemon precluded the laying of the final six miles of track. Thus, rather than go east to its obvious shipping point at Red Bay, the ore had to be dispatched west to Ballymena, for transfer to waggons on the standard-gauge line, and thence to Belfast and Larne for export.

Two years later, in 1878, a narrow-gauge line was opened around the south of the Antrim Plateau between Larne and Ballymena, via

Top: Aerial ropeway terminus at Red Bay, late 1800s. (K. O'Hagan)

Bottom: Retreat railway, east of Cargan. The line is still clearly visible along the left bank of the Cargan Water.

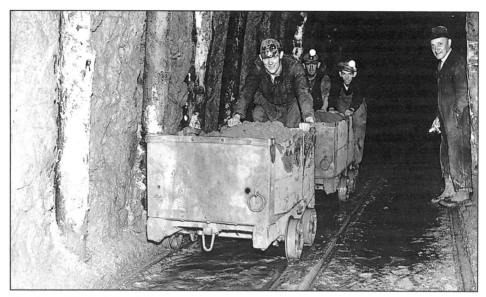

Ore miners. (J. Scally/Belfast Telegraph)

Ballyboley and the Kells Water. This was linked to the Retreat line in 1880, thus permitting the direct conveyance of ore from the mines to Larne Harbour without incurring trans-shipment charges at Ballymena. A further line was also proposed between Ballymena, Broughshane and Carnlough, but was never realized.

Besides the Trostan and Parkmore Sidings (**38a,b**), three other tramways off the main line were constructed in the 1870s and '80s. The Crommelin Siding (**38d**) ran for two miles north of Cargan, and serviced the Crommelin Mining Company's tracts on the south and west flanks of Slievenanee. The Cargan Siding (**38e**) ran for almost two miles along the Ballsallagh Water, serving the Cargan and Dungonnell mines. Finally, the Evishacrow Siding (**38c**) ran for a mile around the south and west side of Binvore Hill, serving the Evishacrow and Ballynahavla mines.

Given the dependence of the Retreat Railway on iron ore, it was highly unfortunate that production declined from 1880, a mere four years after the line's opening. Whereas the line showed a profit of 3s8d per mile in 1880, this was down

to 1s5d in 1890, and a mere 6d in 1893. In 1884, the line was sold off to the Belfast & Northern Counties Railway. In an endeavour to maintain profitability, passenger services were instigated to Martinstown (formerly Knockanally) in 1885, and to Parkmore in 1888 (chapter 7). In 1930, however, passenger services were discontinued. Goods traffic on the Rathkenny – Retreat section ceased in 1937, and the remainder of the line was closed in 1940.

Although the track has long since been lifted, its embanked and incut course is still very evident, particularly between Cargan and Retreat, along with the masonry abutments of countless bridges over streams and accommodation tracks. Several points are of interest (**37a–c**): the embanked stretch south-west of Essathohan Bridge, the bridge itself, Parkmore Station and Retreat Terminus.

The various sidings are also tracable over much of their courses. Of particular note is the inclined plane and ancillary winding gear on the Crommelin Siding just north of the Binvore Burn (**38d**). Just north, at the Tuftarney mine, is a substantial stone revetment at the track side which facilitated the transfer of ore from the mine hutches into the tramway waggons (**36f vi**).

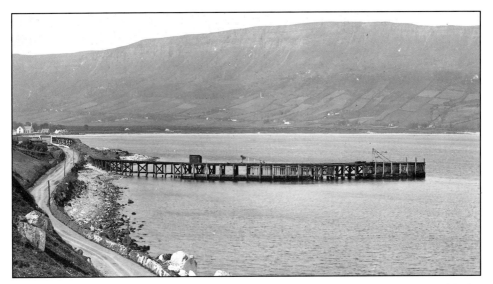

Iron Ore Mining elsewhere on the Antrim Plateau

Ore mining was carried out at a number of sites elsewhere around the scarp of the Antrim Plateau.

Glenariff Mines

In 1873 the Glenariff Iron Ore & Harbour Company began mining operations at Cloghcor, in the upper reaches of Glenariff. In order to transport the ore to the coast, they constructed what was the first 3ft gauge railway in Ireland. This contoured along the southern flanks of the glen, crossing a deep gorge on the high Greenaghan Viaduct. Passing over the main coastal road on the 'White Arch' bridge, the line terminated at Milltown Pier. A terrace of workers' houses was built nearby, and also a shed to accommodate the steam locomotive.

Bad mine management forced the untimely closure of the mines in the early 1880s. Today substantial spoil heaps can still be seen above the tree line at the south end of Glenariff Forest Park (41). The line of the former railway is still very evident along its upper and middle course, especially noteworthy being the tall piers of the Greenaghan Viaduct (42d). The limestone abut-

Milltown pier, early 1900s. Note the White Arch bridge carrying mineral railway over road at left. (NLI: WL 2311)

ments of the White Arch Bridge (42b) are still quite visible, although most of the nearby pier (42a) has been washed away. The engine shed (42c) has now been incorporated into a community hall, whilst the adjacent terrace (43) of former mine- and railway workers' houses continues in occupation.

Garron Plateau

Along the plateau edge between Garron Point and Milltown, many exploratory trial cuts were made by the Antrim Iron Ore Company in the 1870s, some of which developed into small-scale mines. A trial hole is to be seen high up the cliff face in the Crearlagh Gorge at Galboly Upper, and at Carrivemurphy (44b). The most productive mine was Ardclinis (44a) where an inclined plane (44c) conveyed the ore 600ft down the cliff, for conveyance to the now ruinous Fallowvee Pier (44d).

Thin seams, low yields and almost insurmountable difficulties in shifting the ore to the coast, all precluded the long-term development of these mines.

Carnlough and Glenarm

Small trial pits and several adits are recorded above Gortin Quarry and at White Hill, west of Carnlough.

Around Glenarm, the Antrim Iron Ore Company carried on small-scale mining in the later 1800s. Activity is recorded at Unshinagh, Cullinane, and Falmore in Glencloy, and at Glore, Glebe and Libbert West in Glenarm. Only at Cullinane and Glebe, however, do small spoil heaps remain.

Kilwaughter Area

During the 1870s, a number of adits were also worked along the scarp between Agnew's Hill and Shane's Hill, of which little evidence now survives.

Bauxite Mining

Aluminium lends itself to a wide variety of uses on account of its strength, lightness and non-rusting. Like iron, it naturally occurs in the oxide form, the principal ore of which is bauxite, and which was commonly associated with the 'pavement' underlying the pisolitic iron ore.

As output from the iron ore mines began to decline in the 1880s, so bauxite was increasingly worked. For the most part, however, it was too highly contaminated with iron to be of much use; only where overlain by lignite was it found to be reasonably pure. On account of its indifferent quality, it was best suited to the manufacture of alum (aluminium sulphate), rather than processing into pure aluminium.[15]

From the 1880s onwards, several mines which had hitherto extracted iron ore exclusively, also began to extract bauxite. These included the Antrim Iron Ore Company's mines around Trostan, and the Crommelin Mining Company's undertakings at Essathohan, Spittal's Drift, Cargan, Evishacrow, Tuftarney, and Parkmore. A new mine was also opened by the Crommelin Mining Company on Skerry Hill, just north of Newtown Crommelin. Elsewhere, the Eglinton Chemical Company worked the Cullinane and Libbert

Iron ore and bauxite production in Co. Antrim, 1860–1945. (after H.E. Wilson)

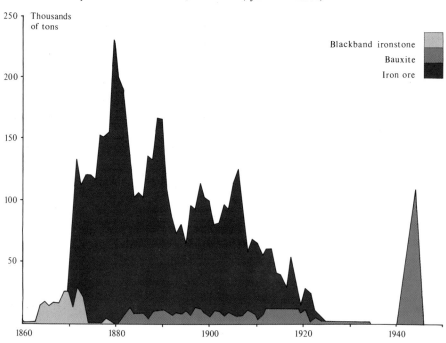

Mines to the east and south of Glenarm respectively.[16] With the exception of the Tuftarney and Libbert mines, spoil heaps survive in all instances.

Bauxite production peaked in 1883, with an output of 13,500 tons, and again during 1917 with 15,000 tons. Although iron ore mining ceased in the 1920s, bauxite mining continued into the 1930s, the Essathohan mine being the last to close in 1933. In all, some 300,000 tons of aluminium ore had been mined in the area.

The need for aluminium-framed aircraft during World War II created an unexpected revival in bauxite mining. The principal mine was at Lyles Hill, near Templepatrick. Within the AONB, a new mine was opened on the eastern flanks of Skerry Hill (**36g**), the substantial terraced spoil heaps of which are still evident on the slopes above the road. Between them, the mines produced almost 300,000 tons of ore (equivalent to 60,000 tons of aluminium) in the period 1941–45, as much as had been produced in the entire period of pre-War working.

Collapsed entrance to bauxite mine, Skerry East.

1.3 Limestone Quarrying, Kilns and Whiting Mills

During the Cretaceous period, some 100 million years ago, much of Co.Antrim was overlain with White Limestone. Commonly known as 'chalk', it was subsequently covered by basalt, and is now only exposed west of Ballycastle, at Murlough Bay, Knocklayd, and along the coastal scarp between Waterfoot and Larne.

Although used to some extent as a local building stone, the chalk is inferior to basalt in this respect. Until the earlier 1900s, it was mainly burnt for use as fertilizer and in lime mortar. It was also quarried on a larger scale for industrial purposes from the mid-1800s onwards.

Burnt Lime

When spread over a field, chalk (almost pure calcium carbonate) reduced the acidity of the area's peaty soils, to the betterment of cereal cultivation. To make it usable, it was necessary to reduce the quarried rock to relatively small particles. It was impractical, however, to set up expensive crushing machinery at every quarry, or indeed to transport the bulky rock to a central processing unit.

Fortunately chalk could also be reduced by subjecting it to intense heat. For this purpose lime kilns were erected adjacent to most quarries. These are invariably of rubble basalt or chalk construction, with a circular charging hole on top and draw hole at bottom. For ease of filling, they were often cut into the hillslope, the back of the slope acting as a ramp to the charge hole. Having started a fire inside the kiln, alternate layers of chalk and coal (sometimes peat and lignite) were added continuously. The resultant powdery mixture was removed at the draw hole and dispatched throughout the area for spreading on the fields.

Their operation is vividly described by the novelist William Thackeray in 1842: 'As one travels up the mountains at night, the kilns may be seen lighted up in the lonely places, and flaring red in the darkness.'[17]

Burnt lime is also the primary ingredient of lime mortar. During the 1800s, this superseded clay as the jointing material for masonry walls. When removed from the kiln, the now-calcined chalk is in the form of quicklime (calcium oxide). Slaked with water, it transforms into calcium hydroxide. Lime wash was made by mixing it with water and coloured pigment. Lime putty was made by incorporating it with sand, for use as a building and plastering mortar. Once applied, it slowly reverted to calcium carbonate, giving a strong durable finish.

Where the Chalk comes close to the surface, numerous small quarries abound, for example at the foot of the seacliffs west of Ballycastle (a tramway linked it with the harbour), on the slopes of Knocklayd and Lurigethan, and in the area west of Carncastle. Many small lime kilns also survive, particularly between Carncastle and Larne, and in the vicinity of Ballycastle and Murlough Bay where coal was readily available. A typical kiln is to be seen at Bighouse (16), beside the track to Murlough Bay. A very prominent example is also visible on the scarp above Lemnalary (54) to the north of Carnlough.

Lime kiln, Lemnalary.

With the increasing use of Portland cement, crushed limestone and artificial fertilizers during the present century, these small quarries and kilns have long ceased to function.

Industrial Uses

Chalk was undoubtedly used by Hugh Boyd in his glass works at Ballycastle in the later 1700s (chapter 4). From the mid-1800s onwards, Chalk began to be utilized on a much larger industrial scale, and very large quarries are to be found above Cape Castle on the slopes of Knocklayd (22) and in the vicinity of Glenarm, Carnlough, and Kilwaughter.

The Eglinton Limestone Company has been to the fore in much of this development. Their Demesne Quarry (64), to the north of Glenarm Castle, is one of the few quarries still active in the region. On the roadside below the quarry is a magnificent set of four contiguous kilns, now defunct. A now-abandoned quarry is concealed in the wooded seaward slopes to the east.

The Company has only recently ceased quarrying at the Town and Mill Quarries (68) just east of Glenarm. Some of this stone was used in the building of Queen's University's Ashby Institute. The roadside Whiting Mill remains very much in operation, drawing stone from the Demesne Quarry. Here the chalk is pulverized into a very fine white powder for use as an industrial filler in a wide range of products such as paint, putty, cosmetics, linoleum, toothpaste, and even flour. Although the mid-19th century water-powered whiting mill has long been superseded by more modern crushing machinery, its millrace (69) is still a prominent feature along the southern slopes of the Glenarm Valley; at over four miles in length, it is undoubtedly one of the longest in the Province.

Quarried limestone was also exported from the harbour and from a small jetty opposite the whiting mill, the stone being conveyed from the Town and Mill Quarries on a mineral railway (little trace of which now survives). Its main destination was Britain where it was used as a flux to draw off impurities during iron smelting.

26

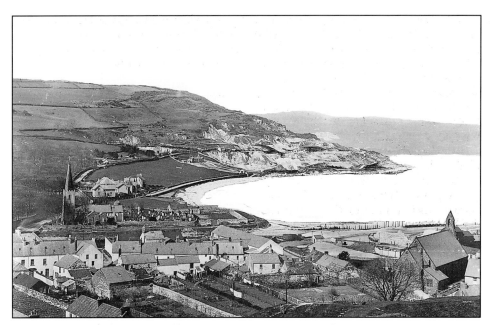

An early 1900s view of the limestone quarry at Parishagh, Glenarm. It is now camouflaged with trees. (UFTM: WAG 1137)

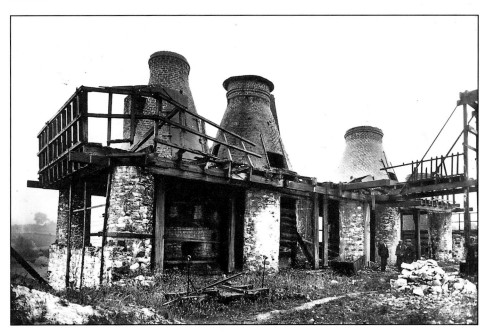

Lime kilns, Carnlough, early 1900s. (UM: W01/29/4)

Even more impressive quarries are to be found above Carnlough. Clearly visible from the Coast Road to the south, the Gortin and Creggan Quarries (56) were formerly also operated by the Eglinton Limestone Company. Their development owes much to the Londonderry family who constructed the present Carnlough Harbour (chapter 7) in the 1850s. This they linked to the quarries by a mineral railway (57), the inclined course of which is still very evident. Two fine limestone bridges carry the line across High Street and Shore Street, the latter with a plaque commemorating its erection in 1854. From the harbour the chalk was exported as a building stone to Britain.

Any stone of inferior quality was burnt in several large kilns adjacent to the railway line. Sadly these were demolished in the early 1980s, the stone being used in the renovation of the harbour; only spoil heaps now remain to mark the site. Fortunately, however, an earlier kiln (58) survives just off High Street. A whiting mill formerly also stood beside the railway on the outskirts of the town; demolished in the 1960s, the site is now a car park.

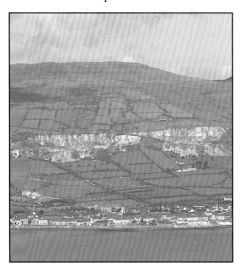

Aerial view of Carnlough, 1960s. Gortin and Creggan limestone quarries are prominent above the town. The brick chimney of the now-demolished whiting mill is at bottom centre. To its left runs the former mineral railway, past the lime kilns, also now demolished.

At Tullyoughter (61), south of Carnlough, is yet another large limestone quarry, also once used by the Eglinton Limestone Company. A mineral railway (62) linked it to Carnlough Harbour, joining the line from the Gortin Quarry at the former whiting mill. On the banks of the Glencloy River below the quarry are two terraces of workers' houses known as Tullyoughter Row.

Although the large kilns at Kilwaughter (88), south-west of Larne, are long gone, quarrying and crushing operations are still continued by the Kilwaughter Chemical Company, with the production of fertilizer and industrial fillers.

1.4 Miscellaneous Quarrying

The extensive sandstone outcrops along the coast east of Ballycastle were worked to a limited extent for building stone, as were several small quarries inland from the town. The stone has an attractive red-brown appearance, and is seen to good effect in the various bridges in the district (particularly the Bonamargy Bridge over the Margy River), and at the Holy Trinity Church in the Diamond, erected in 1756. Scythe stones were also manufactured in the early 1800s.

Numerous basalt quarries abound throughout the region. Very durable, the stone was generally used in its rubble form, for field walls, retaining walls and bridges. Many buildings also incorporated roughly dressed blocks, and it was also crushed for road ballast.

Boyd's mid-18th century harbour at Ballycastle derived its stone from a basalt quarry on the site of the present harbour car park. A wooden tramway, said to have been the first in Ireland, conveyed the stone to the building site. At Glenarm, a tramway also connected the basalt quarry (above the limestone quarry) to the harbour.

A number of sand and gravel pits are to be found in the valleys south of Ballycastle where glaciers have left deposits of clean, well sorted material. Unfortunately, sand is also drawn from the beaches, thereby accelerating coastal erosion.[18]

References

1. For a detailed geological description of the area, see W.B. Wright, 1924, *The Geology of the Ballycastle Coalfield* (Dublin: Stationery Office); H.E. Wilson and J.A. Robbie, 1966, *Geology of the Country around Ballycastle* (Memoir of the Geological Survey of Northern Ireland. Belfast: HMSO).

2. Fuller details of the Ballycastle Coalfield are to be found in G.A. Wilson, 1951, *The Rise and Decline of the Ballycastle Coalfield and Associated Industries, 1720–1840* (Unpublished MA. thesis. Belfast: Queen's University). Outline summaries are given in G.L. Davies, 1957, The town and coalfield of Ballycastle, Co.Antrim (*Irish Geography*, 3: 206–15); C. Dallat, 1975, Ballycastle's 18th century industries (*The Glynns*, 3: 7–13); Wilson and Robbie, Ibid.

3. Dublin's demand for coal also led to the construction of the Newry Canal in the 1730s to facilitate the transport of Coalisland coal.

4. J. Dubourdieu, 1812, *Statistical Survey of the County of Antrim:* 74 et seq. (Dublin).

5. 1830s' *Ordnance Survey Memoirs* for Ramoan and and Carncastle Parishes.

6. A trial open-cast lignite pit was opened near Crumlin on the east side of Lough Neagh in the 1980s. Although commercial exploitation has yet to take place, a further mine has already been proposed for the Ballymoney district.

7. Summary details of the history of iron ore and bauxite mining in Co.Antrim are to be found in K.J. O'Hagan, 1980, The Iron Mines of Glenravel (*The Glynns*, 8: 5–10). For fuller details, see H.E. Wilson, 1961–64, The rise and decline of the iron and bauxite industry of Co.Antrim (*Proceedings and Reports of the Belfast Natural History and Philosophical Society*, 7: 14–23); J.K. Scally, 1954, *The Economic Geography of the Iron Ore and Bauxites of Co.Antrim* (Unpublished MA thesis. Belfast: Queen's University). The historical discussion presented here is largely based on these sources.

8. A. Smith, 1983, *Interbasaltic Mine Workings – Surface Hazards* (Open file report no.69. Belfast: Geological Survey of Northern Ireland).

9. Ferruginous bauxite can, however, be red, and thus of similar appearance to iron ore. For more detailed geological descriptions, see: G.A.J. Cole et al., 1912, *The Interbasaltic Rocks of North-East Ireland* (Dublin: Stationery Office); V.A. Eyles, 1952, *The Composition and Origin of the Antrim Laterites and Bauxites* (Belfast: HMSO).

10. For a detailed discussion of the economics of mining at Glenravel, see D.P. McCracken, 1984, The management of a mid-Victorian Irish iron ore mine: Glenravel, Co.Antrim (*Irish Economic and Social History*, 11: 60–72).

11. The Parkmore and Evishacrow companies were eventually taken over by the Antrim Iron Ore and Crommelin Mining Companies respectively.

12. For details of these north coast mines, see Smith, Op.Cit; H.E. Wilson and P.I. Manning, 1978, *Geology of the Causeway Coast* (two volumes. Belfast: HMSO).

13. K.J. O'Hagan, 1987, The Cargan to Red Bay Wire Tramway – a unique photograph (*The Glynns*, 15: 59–62).

14. Fuller details of the railways and tramways cited in this section are to be found in E.M. Patterson, 1968, *The Ballymena Lines* (Newton Abbot: David and Charles).

15. Around 1900, the British Aluminium Company set up a processing plant at Larne. Here a limited amount of Antrim bauxite was processed into alumina (aluminium oxide), for export to Scotland where the pure aluminium was extracted by electrolysis. However, the bulk of the factory's bauxite was imported from other countries. Although red oxide pigment continued to be produced until closure in 1960 (giving the name 'Redlands' to an area near the harbour), bauxite processing ceased in 1946.

16. Bauxite was also mined around Ballintoy on the Causeway Coast in the first decades of present century.

17. W.A. Thackeray, 1843, *The Irish Sketch Book 1842:* 357 (London: Smith, Elder & Co).

18. W. Carter, 1991, *Shifting Sands: A Study of the Coast of Northern Ireland from Magilligan to Larne* (Belfast: HMSO).

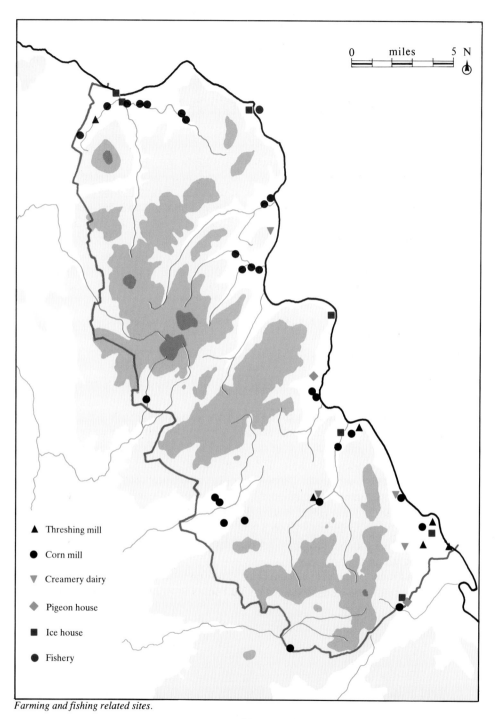

0 miles 5 N

▲ Threshing mill

● Corn mill

▼ Creamery dairy

◆ Pigeon house

■ Ice house

● Fishery

Farming and fishing related sites.

2

FARMING AND FISHING

In North-East Antrim, as elsewhere in Ireland, agriculture has always been the dominant occupation. Whereas emphasis is now on cash crops, quotas, and specialization, a mixed subsistence strategy was pursued in the past, supplemented along the coast by fishing. Potatoes, oats, flax and hay were the mainstays, supplemented with barley, wheat and beans. Cattle and sheep were grazed extensively, whilst hens and the inevitable porker were kept about the farm.

Field drainage and use of artificial fertilizers belie the fact that the area's soils and cool wet climate are not particularly conducive to agriculture. In the past, of course, farmers did not have recourse to modern technology, but relied on the judicious use of manure, seaweed and lime to condition the soil.

Until the recent past, farms were of necessity largely self-sufficient. By today's standards, the diet was somewhat monotonous, milk, oatmeal and spuds being the mainstays, supplemented with eggs, meat, mutton, bacon and the occasional salted herring. The plainness of the diet was further exacerbated by the seasonality of fresh foods, drying, pickling, smoking and salting being necessary to extend their availability through the rest of the year.

Crops and animals were generally processed on the farm: corn was threshed, milk made into butter, and animals butchered in the autumn. Some outside dependence was, however, necessary: grain was ground at the local mill, and (during the present century) milk dispatched to the creamery. The town and village also played an important role in the agricultural economy. Here surplus staples and cash crops such as flax were sold at the weekly market, labourers and servants hired, and equipment, luxuries, and spirits bought.

In contrast to the common folk, the landed gentry had access to a wider range of local foods and were in a position to import provisions which we now take for granted. Moreover, ice houses associated with some of the larger houses provided almost-fresh foodstuffs over the lean winter months.

Until comparatively recently, a number of small commercial fisheries also operated around the coast, often being associated with ice houses in which the fish were preserved.

2.1 Corn and Threshing Mills

Oats, barley, wheat and rye were all grown to some extent in the Glens. Oats predominated, being best suited to the climate and soils. They were used in various forms – crushed or rolled as horse and cattle feed, and milled into oatmeal for oatcakes and porridge.

Threshing mills

Once harvested, the sheaves of corn were threshed to separate the grain from the chaff and straw. Initially this was done with hand flails, but from the later 1700s onwards, mechanical barn threshers were used, powered manually, with animals, or by water power.

One such water-powered threshing mill is to be seen at Blackcave North (82), on the Coast Road near the tunnel. Although the barn is now gutted of machinery, its wheel is clearly visible on the end gable.

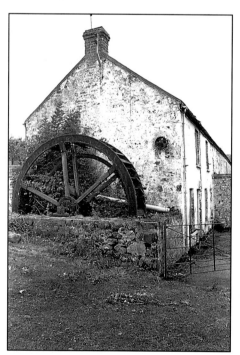

Threshing mill, Blackcave North.

During the present century such mills were superseded by mobile threshers operated in the field. Today, of course, yet more sophisticated machines harvest and thresh simultaneously.

Corn mills

Milling was the next process. Whilst it was possible to buy meal and bread in most villages, even in the early 1800s, most people depended on the home-made product. However, grinding with a handquern was a slow and tedious task, and it was more convenient to take the corn to the nearest mill, invariably water-powered.

Milling has a long history in this area. What appear to be horizontal mills have been uncovered by archaeological excavation at Deer Park Farm (Glenarm), and Killylane (Glenwhirry Valley).

Of more recent corn mills, almost 30 are known, located in the fertile river valleys near to population centres such as Ballycastle, Cushendun and Cushendall.[1]

An adequate flow and fall of water were necessary to provide the 5–10 horse power required to drive the millstones. A steady supply was assured by the the extensive peat uplands which acted like a sponge, slowly releasing the winter rains over the summer months. In most instances, falls were artificially created by erecting a weir across the river. Elsewhere, a natural waterfall served the same purpose, the mill being located immediately below. A good example of the latter is to be seen at Dickey's Town Mill (70), the enigmatic shell of which survives on the Altmore River above Glenarm.

All the mills now surviving in the area were constructed in the later 1700s and early 1800s. In several instances even earlier sites are known, as at Ballindam, north of Cushendun, which dates to the 1600s. The present Ballycastle mill occupies the site of a mill cited on a 1730s' map. Both localities are still known as 'Milltown', and at Carnlough the locality of a former mill (now a house) is known as 'Mill Tenement'.

Most mills were erected by the local landlord. Cushendall mill, for example, was erected by

Francis Turnly around 1830 as a replacement for another mill north-west of the village. Nicholas Crommelin spared no expense in erecting a mill at Newton Crommelin (35) in the 1820s. The 1835 *Ordnance Survey Memoir* describes its millstones as 'capacious' and the kiln as 'excellent'; the wheel was an impressive 24½ft in diameter by 5ft wide, linked to double drive gears.

The landlords' efforts were not entirely benevolent, as they derived income by renting out the mills. To ensure that the miller had business, the landlord bound his tenants to take their corn to his mill, a custom known as 'milling soke'. Although some customers doubtless bartered to have their grain milled, it was more usual for the miller to retain a proportion (multure) of the grain or meal. This he could then resell, and so pay the rental. As the 1800s progressed, the tenants' obligation was gradually relaxed, and cash payments to the miller became the norm.

The mills, although of small grinding capacity and water dependent, were well suited to this small-scale toll milling. Eighteenth and early 19th century mills generally contained one or two sets of millstones, powered through wooden gearing from a waterwheel some 12–14ft diameter by 2ft wide. Later mills usually had three sets of stones, cast-iron gearing, and wheels 15–18ft in diameter by 4–5ft wide. Invariably there was a kiln adjacent, in which the grain was dried to facilitate milling.

With the shift from arable to pasture in the later 1800s, easier procurement of meal and flour thanks to better transport, and decline in home baking with the inception of mobile shops, the demand for corn mills diminished. Only a handful of mills survived into the present century, several of which worked until the 1950s. The crushing and rolling of animal feeds gradually supplanted meal and flour milling, although this too is now at an end as the large feed merchants have expanded their markets.

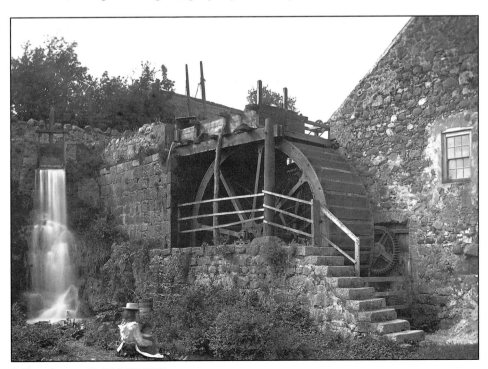

Ballycastle cornmill. (NLI: WL 7025)

Many mills have now disappeared, only their associated races (lades) marking the sites. Others survive as ruinous shells, or as farm outbuildings and house conversions. Only two mills survive intact, at White House (27), half a mile west of Cushendun, and at Coolnagoppoge (18), on the Carey River south-east of Ballycastle. The former was erected on the Dun River in 1847, its wide 16ft waterwheel driving three sets of stones. By contrast, Coolnagoppoge mill has only a single pair of stones, operated by a 12ft wheel.

2.2 Creameries

The manufacture of butter was generally carried out on the farm using a simple up-and-down dash churn. In at least two instances, however, water rather than manual power was seemingly harnessed to drive the churn.

At Lagflugh, north of Cushendun, are the traces of a small millpond said to have powered a churn in the early 1800s. The 1835 *Ordnance Survey Memoir* for Carncastle also notes a 6ft diameter waterwheel as powering a churn on a farm at Ballyruther, near Ballygalley. In neither case do remains of buildings survive.

On a larger scale, an early 1900s roadside creamery near Carncastle has been converted to a dwelling. Despite some structural alterations, its utilitarian concrete walls indicate its very different origins. In upper Glenarm, the Deerpark Co-Operative Creamery, founded in 1909, still continues to function, producing milk powder, buttermilk, skimmed milk and cream.

2.3 Pigeon Houses

Whereas farmers now regard pigeons as pests, in the later 1700s and 1800s they were actually induced on to some estates by the erection of pigeon houses (also known as dovecots). The provision of nesting boxes encouraged the birds to take up residence, and although still free to come and go, their homing instinct ensured their unfailing return.

Pigeon pie was doubtless a welcome addition to the dinner menu, breaking the monotony of salted meat and fish. Additionally, the droppings provided an extremely rich fertilizer, and the feathers a comfortable pillow.

During the 1800s, advances in agriculture and the introduction of root crops such as turnip enabled increasing numbers of livestock to be overwintered. Dependence on the pigeon consequently declined, although the houses were often retained as decorative landscape features.

Two pigeon houses are known within the AONB.[2] One, at Lemnalary to the north of Carnlough, has been reduced to its hexagonal foundations; the field where it stands is still called 'Pigeon Field'. A largely intact example is also to be found in the farmyard of Kilwaughter Castle (86).

Pigeon house, Kilwaughter Demesne. (AS)

2.4 Domestic Ice Houses

Ice houses are associated with many country houses throughout the Province. Prior to the use of refrigerators in the early 1900s, the cooling and freezing facilities afforded by the ice house enabled the provision of almost-fresh meat, fruit and fish over the winter months, a most useful alternative to salting and drying.

Many domestic ice houses date to the later 1700s and earlier 1800s, and most are of the same basic form – a vertical brick-lined cylinder, domed at the top and with a drain hole at the bottom for melt-water. Usually set into a north-facing earthen bank (often tree shaded), and accessed along a multi-doored passage, they were well insulated from outside heat. Properly managed, ice gathered from ponds and streams over the winter months lasted well into the summer. Besides hanging food in the ice house itself, ice was also brought into the kitchen for use in cold boxes and in its own right for cooling drinks and making exotic desserts.

Five domestic ice houses are known within the AONB, particularly well preserved examples being found at Carnfunnock (81), Garron Tower (48) and Kilwaughter Castle (87).[3]

2.5 Fishing and Commercial Ice Houses

Fishing was an important adjunct to agriculture. All along the coast, lobsters and crabs were trapped, and trout and herring netted. Salmon was especially prized. Year after year they return to spawn in the freshwater streams and rivers which issue from the Antrim Plateau. The right to net them was retained by the local landowner, who leased out the concession to the highest bidder.

Carrick-a-Rede, on the North Coast, is the most famous of these salmon fisheries. Ballycastle, Torr Head, Cushendun, Cushendall, Carnlough and Glenarm also had nets, several of which continue to function.

Commercial ice houses are associated with the fisheries at Ballycastle (5) and Torr Head (19).[4] These are larger than domestic houses, and are of rectangular plan, with vaulted roofs. Set into the hillside, their thick rubble walls insulated ice well into the summer salmon season. This could then be used as and when required to pack the fish for dispatch to market.

References

1. Background details to many of the area's mills are given in M. McSparran, 1976, Mills of the Middle Glens (*The Glynns*, 4: 17–24).
2. Further details are in J. Irvine, 1986, Pigeon houses and ice houses in Co.Antrim (*The Glynns*, 14: 16–20).
3. Op.Cit.
4. Op.Cit.

Domestic ice house, Kilwaughter Demesne. (AS)

35

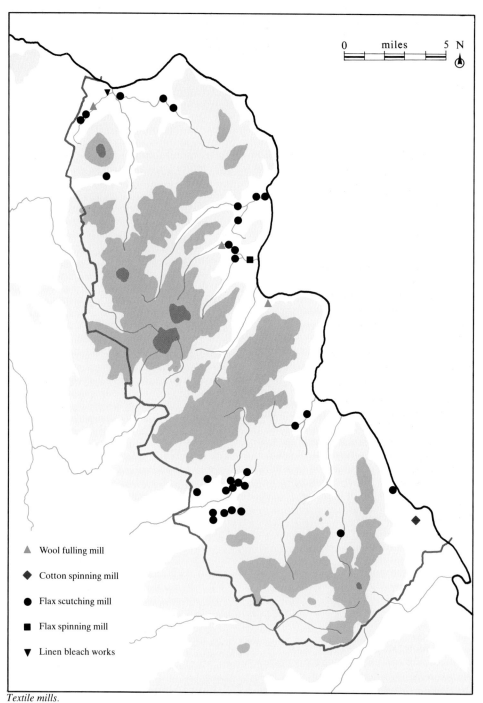

0 miles 5 N

Wool fulling mill

Cotton spinning mill

Flax scutching mill

Flax spinning mill

Linen bleach works

Textile mills.

3

TEXTILE MILLS

Today we take the use of synthetic fibres such as nylon and polyester very much for granted. In the past, however, wool, cotton and linen were to the fore, and all were processed to varying degrees in North-East Antrim.

3.1 Wool

Wool was widely used in garments and blankets. However, with the dominance of linen and cotton, the Province's woollen industry was of no great commercial significance, most activity being focused on domestic spinning, weaving and knitting.

The woven fabric had an open weave, and in order to close up the fibres and make the cloth more durable, it was washed, shrunk and felted. This process, known as 'fulling', was commonly done in a large tub filled with urine, the fullers pounding the cloth with their bare feet.

Tuck mills (also known as walk or fulling mills) mechanized this process, water power being harnessed to drive the fulling stocks. Even in the earlier 1800s such mills were rare in Ulster, and only three are recorded in the Glens, none of which have survived.

3.2 Cotton

In the later 1700s, the domestic spinning and weaving of imported cotton began in Ireland, and by 1800 had become the largest factory industry in the North.

Although the majority of these mills were located near the port of Belfast, a few were found elsewhere, as at Castledawson and Larne. Within the Glens area, a spinning mill was set up near Ballygalley in 1813. The writer of the 1833 *Ordnance Survey Memoir* for Carncastle was evidently impressed, describing it as 'on the principle of the celebrated one of New Lanark in Scotland and is capable of employing from 80 to 100 persons old and young'. Seemingly, mostly women and children were employed, the latter receiving 1s6d a week for a 12½ hour day. The machinery was powered by a massive 22ft diameter overshot waterwheel.

The industry was short-lived however. In the 1820s, import tariffs were abolished, and cheaper English cotton flooded the market. With the inception of the wet-spinning of flax in the later 1820s, linen became predominant.

Not surprisingly, the Ballygalley mill stopped in 1832. It was completely gutted by fire in 1835, and no traces survive.

3.3 Flax and Linen

As with the rest of Ulster, flax was an important crop in the region from the later 1700s to early 1900s. Its transformation into white linen is a lengthy process, requiring retting, scutching, spinning, weaving, bleaching and beetling. Particular areas tended to specialize in specific processes. Many large spinning and weaving mills, for example, were set up in Belfast and along the Lagan and Bann. In North-East Antrim, however, retting and scutching were the main activities.

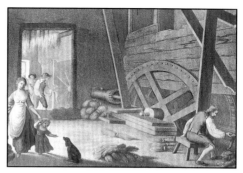

Left: The characteristic 'wee blue blossom' of Irish flax. (Irish Linen Guild)

Top: Flax scutching as depicted by William Hincks, 1783. Flax is passed through rollers (extreme right) preparatory to scutching (left).

Bottom: Removing retted flax from a lint hole, early 1900s. (UFTM: WAG 1062)

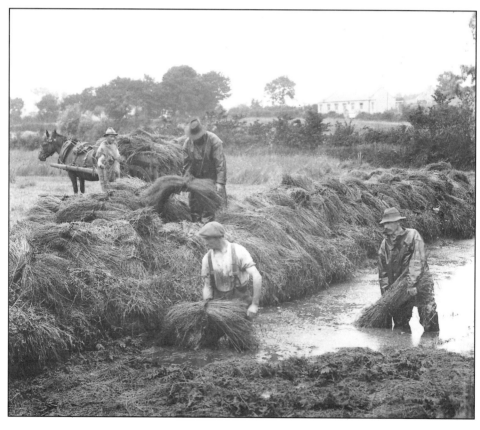

Retting

The retting process involves steeping the bundles of harvested flax in lint holes (also known as retting dams and flax ponds). These small hand-dug ponds were invariably close to running water, from which they were filled. By immersing the flax for up to two weeks, the fibre became loosened from the woody 'shous' which comprised the rest of the plant. The resultant foul smell was unmistakable, particularly when the rotted bundles were removed. In theory the spent flax water could only be discharged when a stream was in flood, although 'mishaps' doubtless occurred, as with silage effluent today. Now-dry ponds are still to be found in the vicinity of Buckna.

Scutching

Only about 10% of the flax plant is usable fibre. As so much was basically rubbish, it made no sense to transport it any great distance to be scutched. Thus, one finds numerous scutch mills dotted around the Ulster countryside, each serving a small locality. In them, the flax fibre was separated from the woody 'shous'.

Within the AONB, over 30 scutch mills are known, the vast majority of which were water powered.[1] Almost half the sites are located in the Braid Valley around Buckna, east of Broughshane. This area supplied the large spinning and weaving mills in Ballymena and Cullybackey. Minor concentrations are also to be found around Ballycastle, Cushendun and Cushendall.

These mills range in date from the early 1800s to Second World War. The earlier ones, of relatively small capacity, would have serviced the domestic needs of the local community, and complemented hand scutching which would have been still widespread. In the later 1800s, however, as flax became a major cash crop, the mills took on a more industrial nature. The scutched flax was then dispatched to market or the nearest spinning mill, many of which were set up in the larger towns, driven by powerful steam engines and water turbines.

The 1860s was a particularly active decade on account of the American Civil War. Cotton supplies from America to the Lancashire mills were interrupted, forcing a greater reliance on linen. With the resumption of supplies after the war, the demand for flax declined. This recession was compounded by the increasing importation of pre-scutched continental flax. The First and Second World Wars again stimulated demand, many defunct scutch mills being reactivated and several new ones built. Today, however, only a small quantity of flax is scutched commercially in the Province.

The scutch mills within the region contained two to six sets of scutching handles, each handle comprising five or six wooden blades mounted on a rotating metal ring. The beet of retted flax was initially put through a set of fluted metal rollers to soften it up for scutching. It was then held over a metal stock set close to the handles which revolved in excess of 100 revolutions per minute. The blades impacted on the fibre, removing the shous and leaving the scutcher with a handful of flax fibre (and hopefully his fingers intact).

Scutching was generally carried out over the winter months. The power requirements of most mills generally did not exceed five horse power. Those with two or three sets of handles had waterwheels 12–14ft in diameter by 1½–2ft wide; five or six handled mills had bigger wheels, upwards of 14–18ft diameter by 4–6ft wide. A double set of gears transmitted the rotation of the slow moving wheel to the fast turning handles.

Although steam, oil and diesel engines had become cheap and reliable by the earlier 1900s, water power sufficed at most mills. It was probably to cash in on the increased demands of the 1860s that a steam-powered mill was erected on the quayside at Cushendun in 1865; ready access to imported coal supplies would certainly not have been a problem. The mill was much larger than the traditional watermill, containing 12 sets of handles and two rollers. It operated until 1884 and the site is now occupied by the Cushendun Hotel.

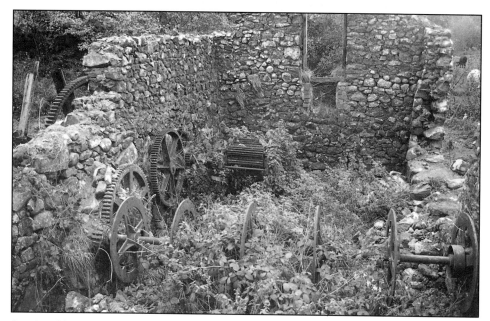

Remains of flax mill, Ballynacaird. The six sets of scutching stocks (foreground) and fluted rollers (centre) are driven through gearing from the external waterwheel (left). (AS)

Of the mills within the area, three-quarters are sites or survive only as shells. Eight wheels remain, the majority with cast-iron axles, hubs and rims, and wooden arms and buckets. Founders' names were sometimes cast on the rim – Christie of Ballymena (at Lough Connelly mill); Kane, also of Ballymena (at Cleggan); and Moore of Coleraine (at Callisnagh). Two particularly impressive wooden-rimmed wheels survive, fine examples of the millwright's craft – at Ballynacaird **(75)** and Buckna **(78)**, with wheels 18ft diameter by 5ft wide, and 20ft by 3ft respectively.

Four mills survive complete, albeit somewhat ruinous – Ballynacaird **(76)**, Cleggan **(72)**, Lough Connelly **(73)**, and White House **(27)**.

Spinning and Weaving

In the 1700s and earlier 1800s, the domestic spinning of flax into yarn was an important supplement to the household income. Whilst the women engaged in spinning, men would have been occupied with handloom weaving when not working in the fields.

It was only towards the end of the 18th century, with the development of the 'dry' spinning frame, that flax spinning became mechanized. In contrast to cotton, progress was hindered by the gummy matter which bound the flax fibres together. Whilst skilled hand spinners had no difficulty in producing fine yarn, such machine-spun yarn was coarser and of inferior quality, albeit adequate for canvas and sail-cloth.

With financial assistance from the Irish Linen Board, some 13 dry-spinning mills were erected in the Province during the first decade of the 1800s. In North-East Antrim, mills were set up at Knockboy (north of Broughshane), Balnamore (west of Ballymoney), and at Cushendall.

The Cushendall mill was erected beside the Dall River by William Young in 1809, on what is now the golf course. However, it appears to have been defunct by 1817. That it was so short-lived is perhaps due to several factors. On the one

hand, there may not have been enough flax grown in the area to keep it in work. There was also the competition from cotton (cf. the Ballygalley mill above). Finally, there was comparatively little demand for coarse yarn. Besides, hand spinners could do a better job and were prepared to work for increasingly less pay. No traces of the site are now evident.

Mechanical spinning of flax was revitalised with the inception of 'wet' spinning in the mid-1820s. By passing the fibre through a trough of hot water, its binding gums melted, allowing it to be drawn out into a fine, but strong, fibre. This paved the way for large steam-powered mills in Belfast, Ballymena, Cullybackey and elsewhere. Their rapid development owed much to the pioneering techniques of the earlier cotton industry: the use of steam engines, labour organisation, and streamlined factory layout.

The production of cheap yarns of fine quality caused the rapid demise of hand spinning. Thus, the 1835 *Ordnance Survey Memoir* for Loughguile Parish notes that spinning 'is resorted to by the industrious more by way of passing the time and to prevent idleness than for the profit of their labour'.

The increase in yarn production did, however, stimulate handloom production, and it was not until the 1850s, with the inception of mechanized powerloom weaving, that this too was hit by competition.

Only in so far as the large spinning and weaving mills stimulated demand for flax did the area benefit in the longer term, by keeping many scutch mills in business right through to the 20th century.

Finishing

When woven, linen retains the brown colour of flax. Doubtless much of it was used domestically in this form, when not dispatched to market. Where white cloth was required, bleaching and beetling were necessary (the latter to give it an attractive sheen). Unlike domestic spinning and weaving, the finishing process was usually industrial in scale. It was comparatively easy to mechanize, as indeed happened in the earlier 1700s.

The entrepreneur Hugh Boyd set up a small bleach works on the Tow River at Ballycastle in the mid-1700s to service local weavers. Doubtless he availed of the locally produced kelp, a rich source of soda ash (sodium carbonate) used in the bleaching process. However, like so many other of his projects, the works did not survive long after his death in 1765, and nothing remained in the 1830s.

As with spinning and weaving, the finishing industry is not recorded within the AONB, being centred, in North-East Antrim at least, on Ballymena, Cullybackey, and Kells.

Embroidery

With the mass production of linen goods in the later 1800s, domestic activity focused on hand embroidery of fancy goods such as handkerchiefs and table linens.

Flowering involved the embroidery of designs in white and coloured thread on to cotton and white linen. Great skill was also needed with drawn threadwork whereby threads were selectively pulled to create decorative patterns.

Bassett, writing in 1888, estimated that some 2500–3000 women were engaged in embroidery in Co.Antrim, the materials being distributed by agents on a piece-rate basis.[2]

References

1. Further details of selected sites are given by M. McSparran, 1976, Mills of the Middle Glens (*The Glynns*, 4: 14–24).
2. G.H. Bassett, 1888, *The Book of Antrim:* 27 (reprinted 1989 by Friar's Bush Press, Belfast).

41

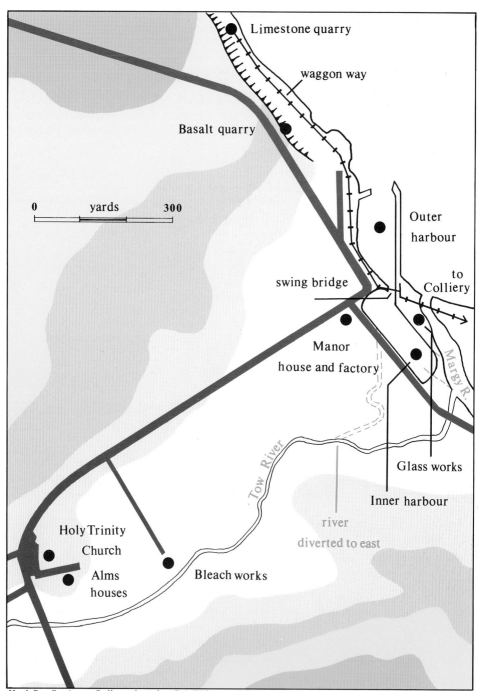

Hugh Boyd's sites at Ballycastle. (after G.A. Wilson and C. Dallat)

BALLYCASTLE'S INDUSTRIAL REVOLUTION

The term 'industrial revolution' is usually associated with later 18th century Britain, which saw innovatory advances in iron working, textiles, coal mining and use of steam engines. These developments had, of course, been many years in the making, and were to continue well into the 1800s. As such, this revolution should be regarded as a 'great leap forward', rather than in its true sense of a 'fundamental reconstruction'.

A true revolution does, however, appear to have occurred in Ballycastle during the 1740s and '50s, instigated and directed by the local landowner, Hugh Boyd.

4.1 Hugh Boyd

Boyd was certainly no stranger to revolutionary times, having been born in 1690. His father was the Rev. William Boyd, rector of Ramoan Parish; his mother owned large tracts of land around Ballycastle. The town itself was brought into family ownership when purchased by Hugh from the Earl of Antrim in 1727.

As already outlined in chapter 1, Boyd had been a colliery manager at Ballycastle in the 1720s. He acquired the coal mining rights to the Ballycastle Coalfield in 1736 and over the next 20 years expanded existing workings, and opened up new seams along the coast between Ballycastle and Fair Head.

It was in an effort to develop markets for this coal (for which he was paid mining royalties), that he set about improving the harbour facilities and developing a number of coal-dependent industries in the town.[1]

4.2 Ballycastle Harbour

Although the export of coal by sea yielded a modicum of profit to the boat owner, this could be enhanced by also importing goods to the town, particularly high value luxury items. This two-way traffic was greatly boosted in 1731 when the Irish Parliament designated Ballycastle a 'Port of Discharge'. This enabled goods on which excise duty was payable to be landed, the Customs House being located at the corner of Quay Rd and North St (it was later incorporated into the Marine Hotel, now totally rebuilt).

There still remained the problem of physically transporting the coal to its point of use. Road carriage from this remote corner of Ireland was out of the question. Moreover, the rocky wind-swept shore was unconducive to the safe berthing of large boats, forcing them to lie at anchor in the bay, the coal being laboriously trans-shipped from smaller boats.

Fortunately for Boyd, the Irish Parliament was then funding projects to facilitate the carriage of Irish coal to Dublin, in order to reduce dependence on more expensive English coal. It was on this basis that Boyd received grant-aid towards the erection of a harbour at Ballycastle.

Its construction began in 1737, and comprised an outer pier and inner harbour. The latter occupied the former mouth of the Margy River which was diverted to the east in order to reduce silting. Much of the stone used in its construction came from an adjacent quarry (where the harbour car

park now stands), horse-drawn on a rudimentary tramway. Boyd even built a ship to transport suitable timbers to the site. The exceptional width of what is now Mary St is due to the fact that, then being a quay, room was necessary for ships' bowsprits and cargo storage.

Unfortunately, the wooden piles of the outer pier were subjected to persistent shipworm attack, causing parts to be washed away in heavy seas. Despite continuing repairs, the inner harbour was eventually opened for business in 1743, and could accommodate upwards of 40 boats.

Coal was, of course, the main export, in excess of 5000 tons being exported annually between 1740 and 1765. Not only did the mines benefit from the harbour, but also the salt pans, the importation of rock salt now being much easier (chapter 6). The export of coal also made it economically viable to set up salt works elsewhere around the Irish coast.

4.3 Ballycastle Industries

With the development of the mines, and completion of the harbour, the stage was now set for Ballycastle's industrial revolution. All the necessary prerequisites were at hand: raw materials, access to cheap and plentiful fuel, a pool of labour in and around the town, sea access to outside markets, and, not least, Boyd himself.

As landowner, capitalist, and entrepreneurial visionary, he was at the forefront of developments, having removed with his family from Drumawillan (on the south-western outskirts of the town) to a newly constructed manor house at the corner of Quay Rd and Mary St in 1738. It was in the shadow of his house that he created various industries over subsequent years.

Glass Works

Perhaps the most prominent of all Boyd's projects was the building of a glass works in 1755 on 'Glass Island' at the mouth of the Margy River.[2] The structure comprised a conical brick flue, some 60ft in diameter at base, and standing up-wards of 90ft high. According to the 1835 *Ordnance Survey Memoir* for Ramoan Parish, it was considered one of the largest buildings of its day in the British Isles.

Bottle glass seems to have been the main product, although some of the window glass in Holy Trinity Church is also said to have been made here.

In the 1700s, the primary ingredients of glassware would have been silica (75%), sodium oxide (15%) and calcium oxide (10%), the main sources of which were sand, kelp and limestone respectively. These were all available locally, as was the firebrick for the smelting crucibles, and coal to fire the kiln.

In operation, the raw materials would have been weighted into the crucibles, and inserted into the furnace through arched openings around the kiln base. The tall flue created a considerable updraught which raised the temperature of the coal well in excess of the 1000°C necessary to fuse the ingredients. The molten mass was then gathered on to the end of a blowpipe and formed into shape.

Other Industries

Boyd established a number of other industries at the bottom of Quay Rd, most of them coal dependent and also inter-dependent in terms of production.

The glass works, for example, supplied bottles to a nearby brewery.

Three tanneries were also operative: in the vicinity of the Manor House, in Fairhill St (Tanyard Brae), and at the north side of the Diamond. Their operation implies the slaughtering of animals, and hence a ready supply of animal fats. This was made into tallow, for use in the candle works (chandlery). Many of the candles were doubtless used in the mines.

Boyd's soap works utilized tallow and locally available soda ash (from kelp), salt and coal (fuel). The tallow and soda were boiled together, and the resultant soap separated out by adding brine; this was further refined by washing and boiling.

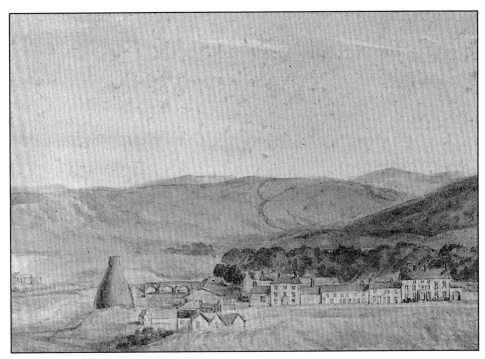

Panorama of Hugh Boyd's sites, Ballycastle, c.1800. To the right of the conical glass kiln is Boyd's manor house and factory complex. (Presbyterian Historical Society)

As mentioned in chapter 3, Boyd also set up a small bleach works beside the River Tow. This was located just south-east of what is now the Ulsterbus depot. Flax seed was imported, the yarn spun and woven by hand, and the linen finished here, ready for export.

A wash mill hereabouts is said to have been powered by the Blind Bridge River, now culverted under Market St and the Diamond. Apparently the Tow itself was too polluted to be of use in the bleaching process; indeed its name implies a link with flax, and was possibly polluted with lint hole effluent. In order to ensure a steady supply of fresh water, Boyd ran a lade off the Glenshesk River and over the Tow to the bleach green.

Boyd also opened a sandstone quarry at Broughanlea, for building blocks and scythe stones. He may also have smelted iron, although whether the ore was imported or local blackband ironstone is unclear.

By the later 1750s, Ballycastle was one of the foremost industrialized towns of Ireland. Even today, few Irish towns could boast such diverse exports as coal, glass, kelp, linen, scythe stones, tanned hides, candles, potatoes, oats and butter.

The traveller Dr Pococke was moved to remark in 1752: 'This gentleman in the colliery and all the manufactures he supports, has about 300 people employed every day ... All these things undertaken and carried on by one man, are a very uncommon and extraordinary instance in a practical way of human understanding and prudence'.[3]

Boyd also provided for the spiritual needs of his tenants, by building the fine sandstone Holy Trinity Church at the Diamond, completed in 1756 and an inn. In his will he also provided for the erection of 20 alms houses just off the Diamond for retired workers.

Holy Trinity Church, Ballycastle.

4.4 Decline

Hugh Boyd died in 1765 and was buried in Holy Trinity Church. Unfortunately for the town, his industries died with him.

Various reasons are given for their demise: lack of interest and business acumen by his heirs, the increasing expense of mining coal, a restricted local market, and competition from English manufacturers. The upshot was that, with the exception of quarrying and coal mining (which continued on a small scale into this century), all his industries had ceased by 1780, and the harbour rendered inoperative by silting.

Boyd's genius was in creating a strong local demand for coal, rather than relying exclusively on exports. His achievements are well summarized by the Rev. William Hamilton in 1790: 'It is likely that Ireland cannot boast of an individual who has more fully discharged his trust, than old Mr Boyd; not possessed of any considerable fortune, nor supported by powerful natural connections, nor endowed with any very superior talents, this man opened public roads, formed a harbour, built a town, established manufactories, and lived to see a wild and lawless country become populous, cultivated and civilized. In the most literal sense, his soul seems to have animated this little colony; in him it enjoyed life and strength . . . This gentleman constructed a most excellent machine, but unfortunately left it without any permanent principle of motion'.[4]

Despite the establishment of a pottery in the early 1800s, it was not until the 1880s, with the coming of the railway, that Ballycastle was given a renewed lease of life as a seaside resort (chapter 7).

Today only shadows of Boyd's pioneering endeavours remain. His Manor House (4a) was described as ruinous in the 1830s *Ordnance Survey Memoirs*. It was extensively repaired and is now a residential home, east of which are the remains of his various factories. The prominent brick chimney was part of the soap works, and was latterly used as a flag turret.

The inner harbour (4b) has been entirely relandscaped as bowling greens and tennis courts.

Most of the outer pier was washed away by the late 1880s, and what survived is now incorporated within a new and extended reinforced-concrete pier.

No vestiges of the bleach works survive, although its name is remembered in Bleach Green Avenue, off Ann St. His alms houses (latterly known as 'Poor Row') in Station St were demolished in the 1950s, and the site is now occupied by a timber yard.

The glass works (4c), which ceased production in the 1790s, were eventually demolished some 100 years later. An excavation in 1973 uncovered the kiln's rubble-stone foundation wall, now conserved, although partly collapsed on to the beach. Fragments of blue-coloured slag can still be found in the wall beside the old ice house at the tennis courts.

Today it is difficult to imagine Ballycastle other than as a seaside resort. Were there to be a memorial to Boyd himself, its auspicious industrial past would certainly be more widely recognized. For the moment, Holy Trinity Church (4d) must remain Boyd's most tangible memorial, although his remains have since been removed to Ramoan Graveyard.

References

1. These industries are discussed in detail by G.A. Wilson, 1951, *The Rise and Decline of the Ballycastle Coalfield and Associated Industries, 1720–1840* (Unpublished MA. thesis. Belfast: Queen's University). Outline summaries are given in G.L. Davies, 1957, The town and coalfield of Ballycastle, Co.Antrim (*Irish Geography*, 3: 206–15; and C. Dallat, 1975, Ballycastle's 18th century industries (*The Glynns*, 3: 7–13).

2. C.A. Dallat, 1974, Ballycastle's glass industry, *The Glynns*, 2: 28–32.

3. G.T. Stokes (ed.), 1891, *Pococke's Tour in Ireland in 1752: 32* (Dublin).

4. Rev. W. Hamilton, 1790, *Letters concerning the Northern Coast of the County of Antrim: 36* (Dublin).

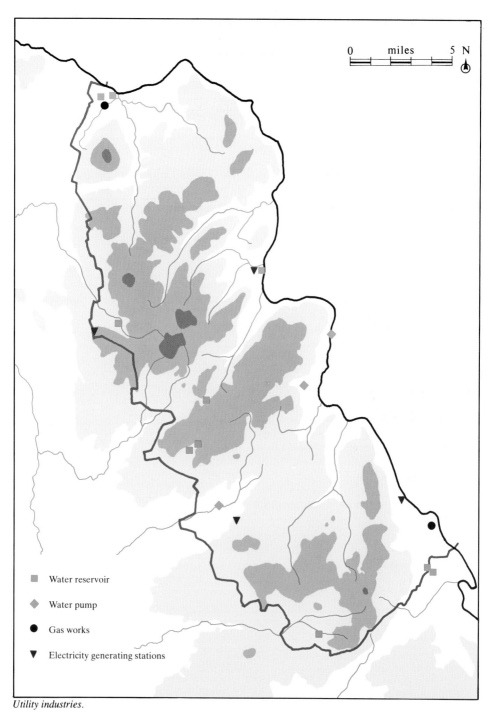

0 miles 5 N

Water reservoir

Water pump

Gas works

Electricity generating stations

Utility industries.

5

UTILITY INDUSTRIES

The provision of water, gas and electricity is now taken very much for granted. However, it is only in the last half century that these services have become routinely available to everyone, in the form of mains water, mains electricity, and bottled gas. Prior to these developments, however, people were dependent on locally generated services.

5.1 Water

Before the piping of mains water supplies to individual houses, people were reliant on streams, springs and wells. Only where there were relatively large concentrations of population was the expense of a purpose-built water reservoir justified. Ballycastle, for example, was initially serviced by two small reservoirs above the town (both now gone). Turnly's Tower (29), in the centre of Cushendall, had a small reservoir on the ground floor which supplied an ornate cast-iron fountain set into the outside wall.

Where a large quantity of water was required, mechanical water pumps were sometimes installed. Although now disused, hand-operated 'cow-tailed' pumps are still a familiar roadside feature in many villages, and along the Coast Road near Larne.

More sophisticated devices were also used, as at Garron Tower (47). Here water was raised to a reservoir in the grounds of the house from a water-powered pump some distance below. Operative since 1854, it has only recently been superseded by electrically driven pumps. Wind-driven water pumps were also used, as for example at the Ammonia Works above Carnlough (chapter 6), and on a farm at Aghacully (74), near Buckna.

In the decades around the turn of the century, large impounding dams were erected across the headwaters of the Quolie above Broughshane, at Ballyboley and at Ballymullock near Larne. More recently, a second reservoir has been built on the Quolie. New reservoirs with water treatment plants have been built on the Bush at Altnahinch, on the Glenwhirry River at Killylane and on the Ballsallagh Water at Dungonnell. These supply Larne, Ballymena, Ballymoney and Ballycastle, and also outlying towns, villages and farms within the region. Although initially erected and maintained by the relevant Town Council, these reservoirs are now operated by the Water Service of the Department of the Environment. In some instances, as at Killylane (89), Altnahinch and Dungonnell, angling facilities have also been developed in recent years.

5.2 Gas Works

Around 1900, some 45 gasworks were operative in Northern Ireland. However, they were restricted to the larger towns and villages to which coal (from which gas was then made) could be readily brought, and which had a large enough consumer base to make production economically viable.

Larne, Ballymena, Ballymoney and Portrush all satisfied these criteria, and within the AONB also Ballycastle. A gasworks was established here by the Ballycastle Gas Company in 1873, supplying not only public street lamps, but also

Wind-powered electricity generator, Slievenahanaghan.

Water-powered pump, Garron Point. Note water in-take pipe, and modern electric pump-house at centre.

Water fountain, Ballygalley.

domestic lights, cookers and heaters. However, it was too small an operation to be economically viable, and ceased operations shortly after the First World War. Superseded by bottled gas and electricity, the site has now been redeveloped.

Some of the larger houses were also able to afford the luxury of coal-gas lighting, as at Cairndhu (south of Ballygalley), the summer residence of Sir Thomas and Lady Dixon, where a production plant was installed in the later 1800s.

5.3 Electricity

Prior to the advent of the National Electricity Grid in the 1930s and '40s, electricity was generated locally, using oil and diesel engines. Water power was also used to some extent, as at Cushendall cornmill, where a water turbine was installed in the 1920s, supplying the village with street-lighting.

At a yet smaller scale, hydro-electricity was also generated at a water-powered sawmill at Ballynacaird (**77**) near Buckna. At Ballyruther, north of Ballygalley, a small pelton wheel also generated for a nearby house until about 1960. Although the volume of water at this last site was small, the power obtainable was greatly enhanced by piping the water down a 100ft scarp to the turbine emplacement below. The wheel is now in the collection of the Ulster Museum.

The Northern Ireland Electricity Service is currently examining the feasibility of generating electricity by wind power on Slievenahanaghan (**34**), north-east of Clogh Mills. Here an 80ft high tower is surmounted by a twin-bladed rotor 75ft in diameter, and capable of generating 400 horse power. Although of insignificant output compared with modern coal- and oil-fired power stations, the success of this prototype may herald the erection of wind farms in Ireland's more remote areas, and so reduce dependence on fossil fuels. Wind-powered electricity is also appropriate for island communities such as Rathlin.

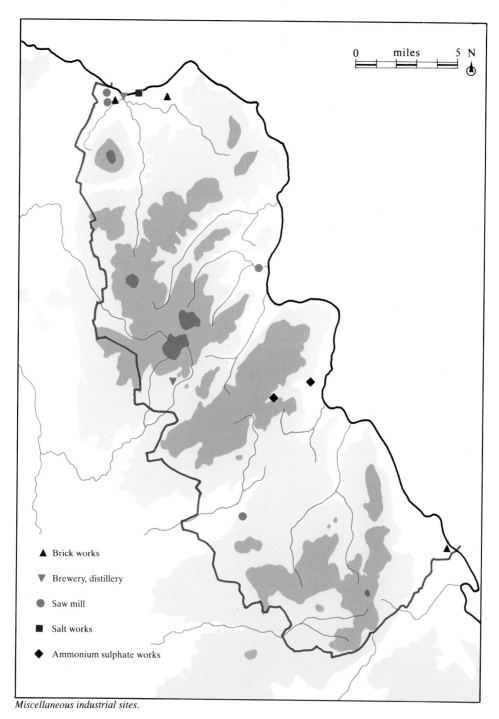

	miles	
0		5 N

▲ Brick works

▼ Brewery, distillery

● Saw mill

■ Salt works

◆ Ammonium sulphate works

Miscellaneous industrial sites.

MISCELLANEOUS INDUSTRIES

In addition to the major extractive and manufacturing activities already described, a number of small-scale industries also operated at one time or another within the region.

Commercial brick making took place at several localities in the later 1800s and early 1900s. In one instance there was also an attempt to set up a distillery. Several saw mills are also known. Three rather more unusual activities are also recorded: salt refining, kelp burning and ammonium sulphate production.

6.1 Brick Making

Until the early 1900s, basalt, sandstone and limestone provided the bulk of the area's building material, although turf sods and mudbrick were sometimes used in poorer cottages. Opportunistic use was also made of suitable clay deposits to manufacture bricks. It was a relatively straightforward, if time consuming, task to dig out the clay, allow it to weather, knead and mould it into shape, and fire the air-dried bricks in crude field clamps.

Hugh Boyd was possibly the first to use brick extensively, when erecting the cone of his glass house at Ballycastle in the 1750s (chapter 4). Unfortunately, it was demolished in the last century. However, a smaller conical brick flue still survives on the mid-19th century lime kiln on High Street, Carnlough (58).

In the later decades of the 1800s, larger-scale commercial brick works appear, with diversification into tiles and field drainage pipes.

At least three sites are known within the AONB, all with good access to clay and coal (whether imported or local) to fire the kilns. At Ballycastle, a Mr Nicholl set up a brick works in the later 1800s on the Tow River beside the railway viaduct. To the east, at Broughanlea, the North Antrim Mining Syndicate began exploiting the clay deposits associated with their coal seams in

the early 1900s. A brick works was also established at Ballycraigy (85) near Carncastle, in the 1880s; it ceased operating in the early 1900s.

At only the last site do traces survive, in the form of the clay pit and line of the former tramway which linked it with the now-demolished brickworks.

All these sites had relatively short lifespans, in part due to competition from cheaper mass-produced bricks imported from Belfast and elsewhere via the railheads at Larne, Ballymena and Ballycastle.

6.2 Breweries and Distilleries

A spin-off from cereal growing was the production of malted barley, a primary ingredient of beer. In the past, brewing would undoubtedly have been a routine domestic activity and there was probably little demand for commercially made beer except in towns.

Only one brewery is, in fact, recorded in the area, established by Hugh Boyd beside his Manor House at Ballycastle in the mid-1700s. How long it operated is unclear, and nothing apparently survives.

Turning to whiskey, the Old Bushmills Distillery is the most famous of the Province's distilleries. As with beer, much would have been made

domestically, and the area is still renowned for the illicit production of poteen.

Within the AONB, two distilleries are known, one of which was associated with Boyd at Ballycastle. The other was at Legagrane (**39**) on the mountainside north of Cargan. This was established around 1840 by Edward Benn, the local landowner, to distil alcohol, not from barley, but from potatoes. Operations were, however, curtailed by the Excise Authorities, and it was in ruins by 1857.

6.3 Saw Mills

Large-scale afforestation, as at Ballycastle, Ballypatrick and Slieveanorra, is a fairly recent development. Prior to this, there was little, if any, commercial tree growing, and consequently only a few saw mills are known.

At Ballynacaird (**77**), near Buckna, a disused water-powered saw mill still survives. Sawing equipment was also installed in Cushendall cornmill in the 1870s.

A third water-powered saw mill below the Tow Viaduct at Ballycastle dates to the 1700s. It was superseded in the 1930s by an electrically powered mill at the Diamond. Whilst no trace of the former survives, the latter (Nicholl's saw mill) is still very much in use.

6.4 Salt Refining

Salt is indespensable both as a condiment, and (until recently) in the preservation of meat, pork, butter and fish. From the late 1700s onwards, it was also increasingly used in the chemical industry, particularly in the manufacture of bleach.

Sea water is a primary source of salt, four gallons holding 1lb in solution. Unlike Mediterranean countries, our climate does not lend itself to salt recovery by natural evaporation of seawater. Artificial heating in salt pans is therefore necessary. Given that 6–8 tons of coal are needed to recover a ton of sea-salt, a plentiful, cheap and convenient fuel source is therefore paramount.

The outcropping of coal seams along the coast to the east of Ballycastle made this area ideally suited to salt production, and it is not surprising to find salt pans in use here since the early 1600s.

During the 1700s and early 1800s, the Irish salt industry greatly benefitted from a tax imposed on salt making in Britain. In Cheshire, rock-salt deposits were being mined, dissolved in water, and evaporated into usable crystalline white-salt. The export of rock-salt to Ireland was, however, exempt from tax. Vast quantities were imported and refined into white-salt, some of which was illegally exported back to Britain. It was in the refining of rock-salt that the Ballycastle salt pans were mainly engaged during the 1700s and early 1800s.[1]

On account of the greatly increased concentration of salt in the brine, only a ton of coal was now required per ton of salt produced, a much more economical proposition than before. The use of seawater in which to dissolve the rock-salt also enhanced the yield of salt. A further economy was to be had by placing the evaporation trough over an active lime kiln. This ingenious practice was seemingly unique to Ireland, but no physical remains of it now survive.

The use of Ballycastle coal enabled salt works to function profitably elsewhere in Ireland. Apart from Ballycastle, they are recorded around the North Coast at Coleraine, Portrush, Ballintoy, Portballintrae, Glenarm, and Larne.

With the repeal of the salt tax in 1825 it became more economic to import white-salt, rather than rock-salt, from Cheshire and elsewhere. The Ballycastle salt works thus ceased to function. Ireland's salt industry also declined, although it revived somewhat with the discovery of rock-salt deposits near Carrickfergus in the 1850s. The Kilroot works is now one of only two active salt mines in the whole of the British Isles, the output of which is used mainly for de-icing roads.

Of Ballycastle's salt industry, the most evident survival is a corroded evaporation trough adjacent to the aptly named 'Pans Rock' at Broughanlea (**11**). A number of localities where salt was refined are documented along the adjacent coastline.[2]

Remains of brine trough, Pans Rock, Broughanlea. (AS)

6.5 Kelp

The term 'kelp' is usually taken to mean the brown tangle of seaweed found around the Irish coast. Certainly, the rocky shore of North-East Antrim ensures a plentiful supply of seaweed, which was often spread directly on the fields as fertilizer, being especially valued for potatoes. Hereabouts, however, kelp also referred to the ash produced by burning seaweed.

Kelp manufacture has been carried on along the coast since the 1700s.[3] The common *Laminaria* species is an especially rich source of soda ash (sodium carbonate), and was used extensively by 18th century bleachers, soap and glass makers. It also contained appreciable quantities of potash (potassium carbonate), which was otherwise derived from wood ash.

Although landowners charged for the right to cut seaweed, and also received a royalty, the high price commanded by the kelp in the 1700s enabled many people to pay their rent, as was the case on Rathlin Island.

With development of the Leblanc method of producing soda from common salt in 1790, and the importation of Spanish barilla, prices fell dramatically during the earlier 19th century. The industry would have come to an end were it not for the discovery, in 1812, that kelp also contained appreciable quantities of iodine. This led to a revival in the industry's fortunes, the iodine being increasingly used in medicines, dyes and photographic materials.

Both cut- and drift-weed were utilized, as described in the 1835 *Ordnance Survey Memoir* for Ramoan Parish: 'Several women assemble early in the morning who collect the seaweed washed on the shore by the tide, or cut it from the rocks when the lowness of the tide admits of them wading out so far. The seaweed thus collected is spread along the shore and when sufficiently dried by the sun it is put into a round kiln formed of sods and stones, about 3ft high in breadth and open at the top, and then set fire to. The weed,

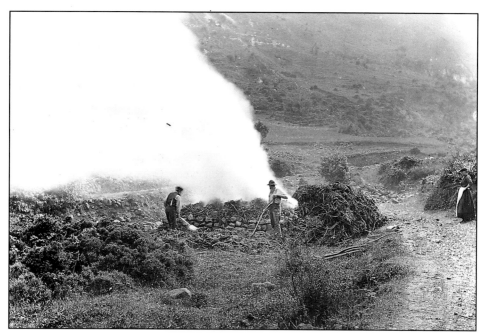

Burning seaweed for kelp. (UFTM: WAG 263)

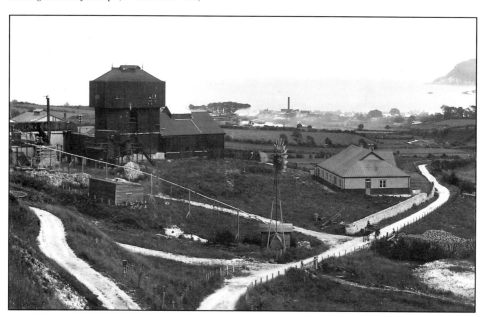

Ammonium Sulphate works, Carnlough. Note the retort house (left), windpump (centre) and manager's house (right). At centre background is the chimney of the whiting mill. (NLI: WL 10109)

from the strong heat, turns into a glutinous mass, and in this state it is suffered to remain until it cools and becomes hard. It is then called kelp'.

The hardened mass was broken up into lumps for easier handling, much being shipped, via handling agents, to Glasgow for further processing. It was a very labour intensive process, as the seaweed could not be mechanically harvested. Twenty tons of wet seaweed (80 cart loads) yielded one ton of kelp, from which upwards of 50lb of iodine were derived – a mere 0.1% recovery rate.

The kelp industry persisted into the present century but proved uneconomic in the face of the cheaper manufacture of iodine from Chilean saltpetre. Kelp has now been entirely superseded by other raw materials and processing techniques.

Most kelp kilns were ephemeral structures, little or nothing of which now survives. At the north end of the quayside at Carnlough Harbour, a kelp store (59) still stands, now in use as a boat house.

Although kelp is no longer produced, seaweed is still gathered for dulse and carrageen, and sold in seaside novelty shops and health food stores.

6.6 Ammonium Sulphate

One of the most unusual industries to be set up in the Glens was the manufacture of sulphate of ammonia at Carnlough in the early 1900s.[4] Vast quantities of peat were cut on the high moorlands above Carnlough and conveyed by aerial ropeway to a processing plant west of the town.

Details of the actual processing method are obscure: the peat was probably reacted with caustic soda in the absence of air, the resultant ammonia gas being passed through sulphuric acid to produce ammonium sulphate, a nitrogen-rich fertilizer.

Although the project was abandoned in 1908, after only six years of operation, substantial traces still survive. At the remote High Station (55a), the shell of the peat workers' accommodation block survives, an incongruous sight in this otherwise desolate landscape. At the Low Station (55b), just below Gortin Quarry, concrete foundations of the processing plant survive. Along the roadside is a large wooden hut, formerly the manager's house. Basal foundations of the two mile long aerial ropeway, dismantled in 1920, can also be found in the vicinity of both stations.

References

1. C.G. Ludlow, 1989, An outline history of the salt industry in Ireland. In *The History of Technology, Science and Society, 1750–1914* (Jordanstown: University of Ulster).
2. D. McGill, 1988, Early salt making in Ballycastle district, *The Glynns*, 16: 17–21; 1989, Early salt making in Ballycastle district II. *The Glynns*, 17: 27.
3. D. Harper, 1974, Kelp burning in the Glens, *The Glynns*, 2: 19–24.
4. L. McNeill, 1980, The Sulphate of Ammonia Co. Ltd. – Carnlough, *The Glynns*, 8: 37–40.

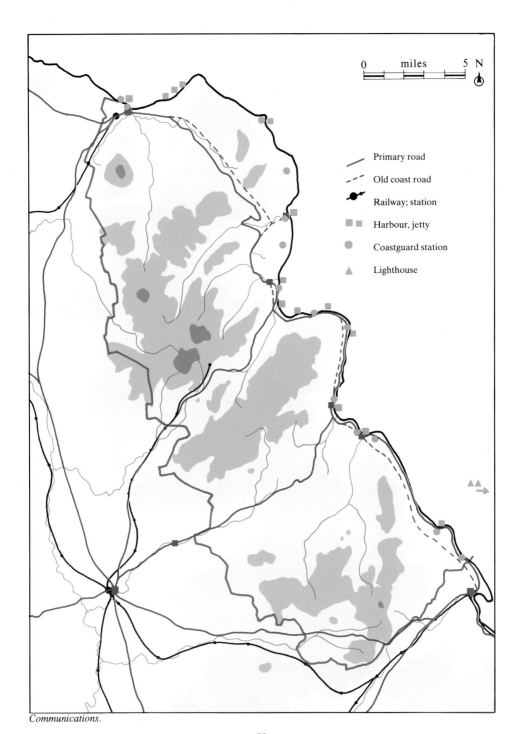

Communications.

7

COMMUNICATIONS

Until the early 1800s, the North-East Antrim coast was relatively isolated from the rest of Ireland, being bounded to the west and south by the inhospitable Antrim Plateau. What commercial intercourse as did take place was generally by sea, along the coast and across to Scotland. The building of the Antrim Coast Road in the 1830s greatly opened up the area, whilst the coming of the railways in the later 1800s also brought greater opportunities for social interaction, commerce and trade.

7.1 Roads and Bridges

The basic road network within North-East Antrim was largely in place by 1800. Although a road ran coastwise from Larne to Ballycastle, steep gradients between the Glens made north-south traffic onerous. Accordingly, the major roads ran east-west, over the Antrim Plateau into the Main Valley. Indeed, in the early 1800s it was probably more convenient to cross to the Kintyre Peninsula in Scotland than to journey to Ballymena.

Most folk, of course, did not need to journey any great distance. Reliant on walking, donkey, and horse-drawn low-back car, the unsurfaced road to the nearest town or village would probably have sufficed.

With the setting up of the Irish Board of Public Works in 1831 and the rationalization of road funding, major new road schemes were instigated, chief amongst them a new route along the coast. Its construction greatly improved communications between towns, stimulating trade and commerce, and paving the way for tourist traffic in the later 1800s (chapter 8).

The Old Larne – Ballycastle Road

The straight-line distance between Larne and Ballycastle is 30 miles. Although the Antrim

Plateau is relatively flat on top, deep incutting along the Glens necessitated a more circuitous seaward connection where the valley sides were less steep. However, frequent landslips and steep rocky headlands precluded any route along the coast itself. Accordingly, the Larne – Ballycastle road, as then existed, was confined to a more inland route, along the margins of the Plateau scarp.

From Larne, two roads ran north-west to Carncastle, one of them over Ballycraigy Hill. North of Carncastle the road ascended the scarp at Sugarloaf Hill, before descending into Glenarm. From here it ran above the coast through Straidkilly to Carnlough, then north to Drumnasole, descending to the coast just north of St. MacNissi's College. It then followed the shoreline to Waterfoot, climbed the headland at Red Bay, and so to Cushendall. Hugging the west slope of Cross Slieve, it then ran to Cushendun. From Knocknacarry, to the west, two roads ascended the Clady Burn north of Glendun, crossing the desolate moorland between Crockaneel and Carnanmore, before descending to Ballycastle along the Carey valley.[1]

Traversing this route involved the difficult negotiation of many steep inclines, as at Ballycraigy Hill, Red Bay, and Glendun. At Pathfoot (71), near Sugarloaf Hill, and the Foaran Path (46b),

Pathfoot incline, Sugarloaf Hill, south of Glenarm. Tracer horses were stabled in the buildings at left.

north of St. MacNissi's College, the road was especially steep, necessitating tracer horses being stabled at the bottom to provide additional traction.

A further problem, common to all roads of this era, was that they were unsurfaced. Heavy rain invariably eroded the surface, particularly on the steeper slopes, necessitating the frequent application of gravel and stone, an expensive and time consuming task.

It was Francis Turnly who first improved the situation in the early 1800s. In an effort to ease his frequent journeys between his Cushendall estates and residence at Drumnasole (near Carnlough), he cut the Red Arch (31) through the sandstone headland at Red Bay in 1817, thus bypassing the steep and narrow incline west of the castle. To avoid the steep Foaran Path, he blasted Turnly's Cut (46a) through a chalk headland in 1822, to create a more gradual descent along a new section of road to the north.

Much of the old route south of Cushendun still serves as a secondary road. Its original character is well seen near Carnlough, where an abandoned 600yd stretch of unsurfaced track runs through the Drumnasole Estate (51) north of Broken Bridge. East of Red Bay is the twin-arched humpbacked Ardclinis Bridge (45), now ruinous. Two unmetalled tracks also cross the desolate moorland between Crockaneel and Carnanmore Mountains (24), north-west of Cushendun.

The New Coast Road

Between 1832 and 1842 a new route between Larne and Ballycastle was constructed. Sometimes referred to as the Grand Military Road (although never put to this use), it is better known as the Antrim Coast Road. This hugged the shoreline to Cushendall, followed the Glencorp valley around Cross Slieve, contoured across the middle reaches of Glendun, and cut over the moorland past Loughareema (the 'disappearing lake') to Ballycastle. The work was directed by the eminent Scottish engineer and surveyor William Bald, and funded by the Board of Works and County Grand Jury to the tune of £37,000. It was then the biggest civil engineering project ever undertaken in Ireland.

Two major civil engineering problems were encountered: the sheer sea-washed cliffs, and unstable geology which caused frequently slipping of the Chalk over the underlying Lias Clays. The Commissioners of Public Works were moved to remark, in 1833: 'this is a road of more than usual importance, both as regards general utility and as a work of considerable difficulty'.[2]

The first problem was solved by blasting back the chalk headlands, as at Ballygalley Head and Garron Point, to form a platform some 20ft wide and high enough above the water to prevent it being washed away. Where the land was subject to slippage, as at Straidkilly (the 'slipping village'), more elaborate construction techniques were employed. First, the base of the slope was excavated and infilled with rock rubble, this acting both as the road platform, and as a barrier to further land movement. To prevent soil ingress over the road, revetments were erected along the landward side of the road. To withstand the pressures, they were curved in both the horizontal and vertical plane and anchored in huge rocks implanted along the rubble base at 30ft intervals. Any soil accumulation behind the wall could then be cleared during regular maintenance.

Particularly noteworthy features along the Coast Road (79) are the Glendun Viaduct (26) and Blackcave Tunnel (83). The former was designed by Charles Lanyon and completed in 1839. It conveys the road 80ft over the Glendun River on three arches, a plaque recording its completion in 1839. South of the Blackcave Tunnel towards Larne, is a roadside plaque erected by the Larne & District Historical Society to commemorate the road's construction by 'the Men of the Glynns'.

Although the Glendun Viaduct is the most impressive of all the bridges in the region, others along the New Coast Road are not without interest. Although modest in scale (mainly single, sometimes twin-arched), they are unpretentiously elegant, constructed in dressed red sandstone with decorative stringing, piers and wall coping. From

south to north they are to be found in the townlands of Ballygalley, Glencloy (**60**), Carnlough, Highlandtown (**53**), Burnside (**52**), Newtown (**50**; of dressed limestone), Ardclinis (**45**; a replacement of the earlier humpbacked bridge), Mullarts, Knocknacrow, Lough, and Ballyvoy (**17**).

Between Glendun and Ballycastle is an interesting sequence of bridges with datestones recording their construction in 1834: Craigacat, Corratavey, Altheela, Bushburn, and Altadreen (**25a–e**). Corratavey is of special interest, being inscribed 'William Bald Engineer', its arch carrying the road high over a small stream, the bed of which is paved to carry vehicular traffic.

Other notable bridges associated with the Coast Road include the twin-arched Cushendall Bridge (**30**), three-arched Bonamargy Bridge (**9**; an 1860 replacement of the earlier bridge), and the four-arched Cushendun Bridge (**28**).

In 1967, rock falls east of Glenarm necessitated the construction of a new line of road out to sea, leaving a wide berm for any subsequent calamities. Unfortunately disaster struck when it was washed away in 1968. It has now been successfully rebuilt with stronger sea walls, and no major catastrophes have recurred. Storm damage to sea walls does, however, necessitate continual repair work, making it one of the Province's more expensive roads to maintain.

Antrim Coast Road at Garron Point.

Other Road Schemes

The period between 1830 and 1860 witnessed many other road improvements within the AONB. New roads, such as that between Armoy and Cushendall, were constructed, and existing roads realigned and interconnected.

Several existing road lines were entirely re-routed in order to avoid steep gradients. Apart from the New Coast Road, notable examples include that between Newtown Crommelin and Cushendall. This formerly ran across the southern flanks of Slievenanee and (what is now) Parkmore forest, along the northern slopes of Crockalough, and down Glenballyemon. During the mid-1800s, it was entirely supplanted by to-day's road which runs at a lower level up the Cargan Water and down the Glen. In the 1870s, the Crockalough section of the old road was reused in the laying of the mineral railway to Retreat.

The old road running south-west along the bottom of Glenariff was replaced by a more gradual incline along the valley's northern flanks. Likewise the Larne – Ballymena road over Shane's Hill and along the north side of Glenwhirry was replaced between Kilwaughter and Shoptown by the present lower-level road around the southern flanks of Shane's Hill and Ballyboley.

The old Kilwaughter – Carnalbanagh road along the Killyglen and Ballytober valleys was superseded as late as 1917 by a new road over Capanagh Hill. A major realignment also took

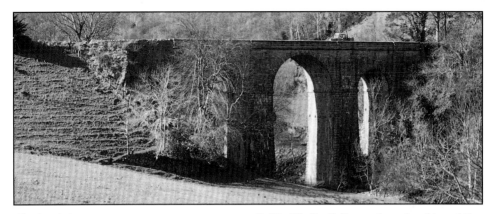

Glendun viaduct.

place in the vicinity of Slanesallagh, three miles north-east of Buckna.

The contrast between old and new is apparent in the latter's gentler gradients and higher standard of construction. Not only are the new roads wider, but their associated bridges are of a superior build. This contrast is clearly evident along the Larne–Ballymena Road west of Shane's Hill. The older bridges at Upper Glenburn and Lowtown are of rubble-stone construction, whereas their newer counterparts – Lower Glenburn and Killylane respectively – are of dressed-basalt with decorative stringing and highlighted voussoirs. Another example of this contrasting style is at Glenariff where the hump-backed Callisnagh Bridge (with its staggered approach; **40**) may be compared with the dressed basalt Altahuggy Bridge to its south-west.

The networking between existing roads was also improved in the mid-1800s by the addition of short connecting links. Several examples are to be found around Glenarm: Carncastle – Knock Dhu – Craigy Hill; Shillanavogy – Drumcrow; Straidkilly – Tamnabrack; and at Deer Park Farms where McCartney's Bridge takes the road over the Linford Water.

Minor realignments are numerous, for example immediately north-east of Newtown Crommelin, where a ford over the Skerry Water was superseded by a basalt bridge to its north. Or again, along the old coastal road just south of St.MacNissi's College, where the old road line can still be distinguished as a soil mark across a field.

Bridges

Over 100 road bridges are to be found within the AONB, carrying roads over rivers and streams. With few exceptions and aside from those cited above, all are of masonry construction, generally single rubble-stone basalt arches over minor watercourses. North and west of Cushendun, with the change in geology, one also finds examples of dressed sandstone.

Substantial bridges are generally only encountered along the coast where the traffic was heaviest, and the water courses at their widest. Aside from those cited above, examples include the twin-arched Waterfoot Bridge (**33**), triple-arched Glenarm Bridge (erected in 1823; **66**), and rubble-stone four-arched Drumahaman Bridge (**10**) over the Glenshesk River near Ballycastle. Other notable bridges include the 18th century Barbican Bridge (**65**) at Glenarm, and the ornate Glenshesk Bridge (**23**), carrying a realigned section of the Armoy-Ballycastle road high above the river.

In the more recent past, several bridges have been superseded by stronger reinforced-concrete structures and piped culverts.

Aside from vehicular bridges, several footbridges are also to be found in the region: across the Dall at Cushendall, and at the mouth of the Margy River (**8**) at Ballycastle.

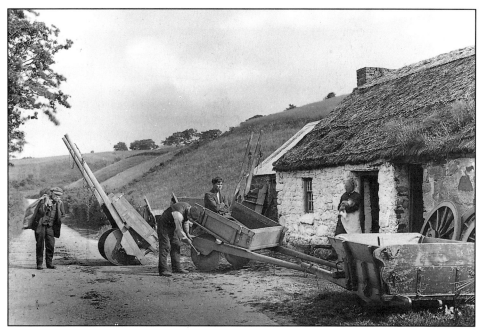

Car builder, Glenshesk. Note the use of solid, rather than spoked, wheels. (UFTM: WAG 1943)

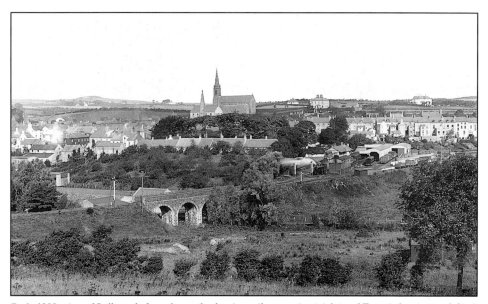

Early 1900s view of Ballycastle from the south, showing railway station (right) and Tow viaduct (centre left). A siding led down the bank to Nichol's saw mill (extreme left). The roofline of 'Poor Row' is also visible between the church and viaduct. (UFTM: WAG 2069)

7.2 Railways

In 1834, Ireland's first railway opened between Dublin and Dun Laoghaire (Kingstown), followed in 1839 by a link between Belfast and Lisburn. The success of these ventures heralded an era of 'railway mania' in the Province during the 1840s and '50s, links being established between Belfast, Dublin, and all the main Provincial towns. It was during this time that the Belfast & Ballymena Railway Company was formed, the two towns being connected in 1848. By 1855 the line had been extended through Ballymoney and Coleraine to Portrush.

Just as motorways today stimulate the economy of the areas through which they pass, so it was with the Belfast – Portrush line, running around the west side of the Antrim Plateau. The line proved a boon not only to passengers (numbering hundreds of thousands per year in the 1860s), but also to industry and agriculture, facilitating the import and export of raw materials, manufactured goods, foodstuffs and livestock.

As outlined in chapter 1, Ballymena was linked by rail with Retreat and Larne in 1876 and 1878 respectively. In 1880 a third line was instigated, between Ballymoney and Ballycastle. In contrast to the mainline 5ft 3in gauge, these three lines were only 3ft across. This narrow gauge was perceived as being cheaper to lay and more economical to run than standard track, particularly where high volumes of traffic were not anticipated.

Ballymena – Retreat Line

As already noted, this line was conceived by the Ballymena, Cushendall & Red Bay Railway Company as a mineral railway to run from Ballymena, via the Glenravel iron ore mines, to Red Bay.[3] In practice, the line stopped at Retreat, and the ore was conveyed via Ballymena to Belfast and Larne.

The line handled goods traffic exclusively until 1884, when it was taken over by the Belfast & Northern Counties Railway (BNCR; formerly the Belfast & Ballymena Railway Co).

With the decline in ore traffic from 1881, the Company instigated passenger services to Martinstown in 1885, and to Cargan and Parkmore in 1888, where new stations were built. It also acquired Glenariff, which, with its silvan gorge and spectacular waterfalls, was actively promoted as a tourist venue. Visitors could travel to Parkmore by train, then transfer to a jaunting car for the last two miles to the Glen, with the option of going on to Cushendall and Garron Tower (which became a hotel in 1899 and is now St. MacNissi's College). They could then return homeward along the Antrim Coast Road to Larne.

In 1903, the BNCR was absorbed by the Midland Railway (which became the London, Midland & Scottish in 1923).

After the First World War, passenger traffic declined markedly, fuelled by increasing competition from buses and motor cars. Passenger services were discontinued in 1930. Goods traffic between Retreat and Rathkenny was suspended in 1937, and on the remainder of the line in 1940.

Interesting features related to the line's mineral traffic operation have already been noted in chapter 1. As regards its passenger era, notable is the waiting room at Parkmore Station (**37c**), an early example of the use of pre-cast concrete.

On the Ballymena – Larne line, passenger services were suspended in 1933, and freight traffic in 1940. Although parts of this line can still be traced, none lie within the boundaries of the AONB.

Ballymoney – Ballycastle Line

Had there been a railway to Ballycastle in 1780, Hugh Boyd's pioneering industries may well have expanded rather than declined. However, it was not until 1880 that the 16 mile link was made with Ballymoney by the Ballycastle Railway Co., via Dervock, Stranocum and Armoy.[4] It had also been intended to connect Dervock with Bushmills and thus link up with the Giant's Causeway tramway from Portrush, but this plan was never implemented.

In the 1880s there were no major manufactories in the town, and the anticipated iron ore and coal

freight never materialized. The railway's profitability relied, therefore, mainly on summer trippers and visitors to the Lammas Fair. Its heyday was from 1890 to World War I, with an average of over 100,000 passengers per year. As with the post-war Retreat Line however, the motor car and bus increased in popularity, and by the 1920s, passengers were down to 50,000 per year.

In 1924 the Ballycastle Railway Co. went bankrupt, and the line closed. However, it was almost immediately reopened by the London, Midland & Scottish Railway and functioned until 1950 when the era of Co.Antrim's narrow-gauge railways came to an end.

A short stretch of line, from Cape Castle northwards, falls within the AONB. Its embanked course is still quite visible contouring around the western slopes of Knocklayd above the River Tow; part of the Moyle Way Footpath runs along it near Ballycastle. Notable features include a tunnel at Cape Castle (**21**), the Tow Viaduct (**7**), and Ballycastle Station (**6**), where the waiting room, engine shed and water tank all survive.

7.3 Harbours, Coastguard Stations, Lighthouses and Marconi

Prior to the development of the area's road and rail network in the mid- and later 1800s, sea travel assumed an importance which it is today hard to imagine. It was vital for the export of agricultural produce, limestone and ore, and for the import of such items as coal, timber, bricks and slates. The various ports, coastguard stations and lighthouses around the coast are testimony to this once flourishing activity.

Harbours, Piers and Quays

In spite of the exposed nature of the Antrim coastline, many small piers and quays are dotted along it. Some were related to seasonal fishing activity as at East Torr, in the sheltered bay south of the headland. Others, such as those at Fallowvee, Carrivemurphy, Tornaroan, and Cross, were purpose built for the export of limestone, coal and ore to Britain.

Red Bay Pier (**32**) was one of the main departure points for cross-channel traffic. It was erected in 1849 to serve Cushendall and Waterfoot, and in the 1860s became the chief export point for Glenravel iron ore. However, trade fell away with the completion of the Ballymena-Retreat railway in 1876. In the 1970s the pier was briefly used for a roll-on/roll-off ferry service to Kintyre, a part of Scotland served from Cushendun Quay in the 1700s and earlier 1800s.[5]

Only at Ballycastle, Carnlough and Glenarm do sizable harbours exist (greatly overshadowed, of course, by Larne to the south). All owe their origins to the endeavours of local landowners, anxious to develop industries through the improvement of cross-channel trade.

As discussed in chapter 4, Hugh Boyd built a harbour and pier (**4b**) at Ballycastle in the 1730s, primarily for the export of coal. Silting was a recurring problem, and the inner harbour was eventually abandoned towards the end of the century, to be succeeded by a small quay and slipway to its west (**3**).

In 1891, McGildowney's Pier was built slightly to the west again. Carried on a metal substructure, it projected into deep water, thus enabling the docking of large ships, such as those on the Londonderry – Ardrossan run.

In the early 1930s, an extension was made to the small pier at the slipway. With the demolition of McGildowney's Pier for scrap during the War, it became the main departure point for Rathlin. Sea swells made berthing difficult, however, and in the 1980s, a replacement pier was erected to the west of McGildowney's former pier.

Carnlough Harbour (**59**) owes its origins to a pier erected by Philip Gibbons in the 1790s for the export of quarried limestone and burnt lime. In the mid-1850s this was largely superseded by the present harbour, financed by the Londonderry family. A mineral railway brought limestone from the nearby quarries directly to the quayside for shipment. The harbour com-

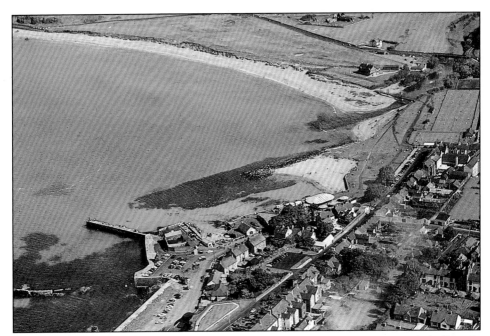

Aerial view of Ballycastle harbour, c.1960. The amenity grounds (top right) occupy Hugh Boyd's harbour, the seaward approach to which is still clearly visible. The basal remains of McGildowney's pier are at bottom left, beside the slipway and jetty. (F. Cox)

plex has recently been refurbished as a tourist amenity.[6]

A pier has stood at Glenarm (**67**) since the 15th century. The present harbour at the mouth of the Glenarm River dates to the 1860s. It, too, was an important export point for limestone and ore. In the later 1800s, silting problems necessitated the building of a smaller pier to its east, opposite the whiting mill (little of which now survives). In places ruinous, the main harbour is now used mainly by small pleasure craft.

In the 1830s, an abortive attempt was made by Nicholas Crommelin to erect a harbour near the sandstone caves at Cushendun. 'Port Crommelin' as it was to be known, was intended to be the main port for Ballymena, his recently established village at Newtown Crommelin being the halfway point. However the village was not a success, and work on the harbour never commenced despite parliamentary sanction.

Coastguard Stations

The collection of customs duties and apprehension of smugglers has long been a preoccupation of Government. In the 1700s and earlier 1800s, there was a flourishing clandestine traffic in tobacco, spirits and tea.

With the setting up of the Coastguard Force in 1822 (an outgrowth of the Preventive Water Guard), permanent look-outs were established around the coast. Each comprised a watch house, boat house, and basic one-storey cottage for the officer and boatmen.

The basalt scarp of the Antrim Plateau provided particularly commanding views to sea, as at Dickey's Town (south of Glenarm) and Garron Point. By using flags, semaphore contact could be made between stations, so keeping track of passing boats.

In the second half of the 19th century, the Board of Works erected a number of more sub-

Coastguard look-out station and flag-staff, Garron Point, as depicted by Andrew Nichol, 1828. The chalk outcrops at centre mark Turnly's Cut. (UM: 160-2957)

stantial two-storied terraces, each with an adjoining watch tower. They were usually staffed by ex-naval personnel, their families also living on the premises.

In two instances (Torr Head and Garron Point), the houses are at a distance from the station proper to afford greater protection from the weather. The Torr Head station (**20**) also doubled as a Lloyd's Signal Station, the details of each passing ship being telephoned to the company's London insurance office. Until the inception of ship-to-shore radio, the station played a vital role in reporting the safe arrival (or otherwise) of cross-Atlantic shipping, and could also advise their captains of the ports which offered the best price for their cargoes.

As smuggling activity declined during the later 1800s, many stations were closed down. During the present century, those that remained assumed an ever increasing role in the protective surveillance of merchantile shipping and fishing boats.

With the relatively recent inception of lifeboat stations at Portrush and Red Bay, and development of helicopter rescue services, coastguard stations have become vitrually redundant, and all within the AONB have been sold off to private developers.

The majority of 19th century coastguard stations survive intact, although often heavily refurbished, as at Aghagheigh (north of Cushendun), Waterford (south of Cushendall), Carnlough and Drains Bay. Largely unaltered terraces survive at Parishagh (**63**; north of Glenarm), Ballygalley (**80**), Garron Point (**49**) and Ballycastle (**1**). The last is particularly impressive, its central look-out tower dominating the skyline above the harbour. The small look-out on the headland west of Ballycastle was the last to operate, closing in the late 1970s.

Although the operations of H.M. Coastguard are now co-ordinated from North Down, a base is still maintained in Ballycastle for air-sea and cliff rescue missions.

Lighthouses

The strong tides and rocky shoreline of the North Channel have long been the bane of sailors, and for this reason several lighthouses were erected to enable bearings to be taken and warn of impending doom.

The Maidens (**84**; otherwise known as the Hulin Rocks), five miles off Ballygalley Head, boasted two lighthouses, both erected in the late 1820s. The West Light was some 100ft above sea level, with accommodation for the keeper and his family in an adjoining house. It was abandoned in 1903. The East Light, almost half a mile away, was also manned by a keeper. Around 1980 it was automated, now being controlled from Larne.

Marconi's Experiments

In the recent past, sea communication has been greatly improved through the development of ship-to-shore radio and satellite tracking systems. A pioneer in radio communication was the Italian Gugielmo Marconi. With George Kemp, he established the first radio communication (using Morse code) between Ballycastle and Rathlin Island in 1898. In making this link across open water, he clearly demonstrated the potential of wire-less telegraphy.

This was of particular interest to Lloyds who operated a lookout station at the East Light on Rathlin. Until then sighting of ships had been communicated by carrier pigeon and semaphore to the Torr Head station, and via land-line to their London heaquarters.

There is some dispute as to where these experiments took place. Although there is a 'Marconi Cottage' along the shore road from Ballycastle to the coal mines, they were actually conducted from White Lodge, off North St, in the town itself. This historic event is commemorated in a Memorial Stone (**2**) at the harbour car park.

East Light, the Maidens. (NITB)

References

1. More fully discussed by J. Irvine, 1973. The old coast road from Larne to Ballycastle (*The Glynns*, 1: 16–20).

2. Contemporary details of the new road's construction are given in the Reports of the Commissioners on Public Works, Ireland, *House of Commons Sessional Papers*, 17 (1833): 373; 40 (1834): 233.

3. The line is detailed by E.M. Patterson, 1968, *The Ballymena Lines* (Newton Abbot: David & Charles).

4. Further details are in E.M. Patterson, 1965, *The Ballycastle Railway* (Newton Abbot: David & Charles).

5. J.E. Robertson, 1978, The Red Bay – Campletown Ferry (*The Glynns*, 6: 39–40).

6. J. Irvine, 1977, Carnlough Harbour development scheme 1854–1864 (*The Glynns*, 5: 22–30).

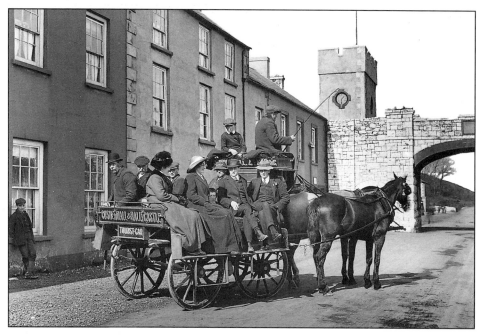

Log-car at Carnlough, early 1900s. (UFTM: WAG 1169)

Glens of Antrim hotel from Dall River, Cushendall, early 1900s. (UM: W01/50/8)

TOURISM

The scenic attractions of North Antrim are renowned the world over: the Coast Road, Glenariff, Carrick-a-Rede and the Giant's Causeway. Although we now live in an era of cheap package tours to far-off locations, with the exception of agriculture, tourism has become one of the area's main industries, providing seasonal employment in accommodation, catering and commerce.

8.1 Early Tourism

The hexagonal rock formations at the Giant's Causeway have been known since the 1600s, whilst the Carrick-a-Rede rope bridge was already providing excitement for the daring in the early 1800s. However, although the Belfast artist Andrew Nicholl painted many scenes around the Antrim Coast in 1828, the area's scenic merits were only brought to wide public attention with the completion of the New Coast Road in the 1840s.

One of the first to exploit the area's tourist potential was Henry McNeill. Born in 1836 at Deerpark, Glenarm, he is widely regarded as the father of Ulster tourism. He organized regular sightseeing tours along the coast in the later 1800s from his several hotels in Larne, then a rapidly developing cross-channel port. In 1899, he acquired Garron Tower, formerly the summer home of the Londonderrys, and opened it as a hotel.[1]

As discussed in the previous chapter, Co. Antrim's rail network was already well established by the later 1800s, with stations at Ballymena (1848), Portrush (1855), Larne (1862), Ballycastle (1880), and Parkmore (1888). By arrangement with the Belfast & Northern Counties Railway (BNCR), visitors could purchase through tickets for McNeill's waggonettes and long-cars at any station.

The BNCR was also instrumental in developing Glenariff as a tourist venue. The company purchased the upper portion of the Glen and installed bridges and paths alongside the various waterfalls, with a tea-room at the bottom. In 1900 a first-class trip from Belfast to the Glen, via Ballymena and Parkmore, and return via the Coast Road and Larne, cost the princely sum of 7s6d; third class was a mere 4s0d.

The railway also proved a boon to Ballycastle. Hugh Boyd's industries having long since collapsed, the town readily embraced the opportunity to become a seaside resort. George Bassett, in his 1888 *Book of Antrim*, notes: 'Since the Railway was opened, there has been a marked increase in the popularity of the place as a summer resort for families. There is excellent bathing accommodation, and innumerable opportunities for sightseeing'.[2] At that time, a number of hotels were in operation, one of which (Baird's in Main St) boasted a pleasure garden and camera obscura (closed on Sundays). A golf course was opened in 1891, whilst the more adventurous could sail around Fair Head.

With Larne and Ballycastle the termini for the Coast Road Tour, the small towns along the route cashed in by selling refreshments, ice cream and souvenirs. Several developed as seaside resorts in their own right, attracting people from Ballymena and further afield.[3]

Carnlough was one such resort. Bassett notes it as: 'one of the handsomest strands in the County, two miles in length, and is a favourite bathing place'. It boasted the elegant Londonderry Arms Hotel (1848); the implicit drawbacks of the Temperance Hotel were perhaps mitigated by its 'superior ice creams'.

Whereas the prospering Carnlough limestone industry does not seem to have affected its development as a resort, this was not so at Glenarm. Regarded, according to Bassett, as one of the county's most popular summer venues in the earlier 1800s, by the later 1800s it was the scene of extensive limestone quarrying. This, coupled with the inaccessibility of the Glen, may have made it less popular than otherwise.

Cushendall also benefitted from tourism. Bassett notes: 'Cushendall is a tourist place of the first rank. The inhabitants, although occupied in farming and other pursuits, are not slow to appreciate the advantages to be gained by catering to the wants of the thousands from all over the world, who annually stop at the village on the way round the coast'. Indeed the town boasted probably the first hotel in the area, the Glens of Antrim Hotel, opened by Francis Turnly in the early 1800s on the Shore Rd.

Tourism's economic boost to this essentially rural area is further emphasized in an advertisement for the Cushendall Hotel carried by Bassett: 'Milk, butter and vegetables fresh every day from the farm belonging to the hotel. Also carefully fed mutton'.

8.2 Tourism Today

The days of excursion trains to Ballycastle and charabancs to Glenariff are long gone, although Ulsterbus still continue the tradition with their summer tours. With today's high level of car ownership and well connected roads, the area is now the venue for caravaners and day trippers en route to high-profile attractions such as the Giant's Causeway Visitors' Centre and Portrush. Fortunately this has not been to the detriment of the area's scenic beauty.

In order to help retain something of the area's unique landscape character for future generations, it was designated an Area of Outstanding Natural Beauty in 1988.[4] Conservation Areas have also been designated in Glenarm, Carnlough, Cushendall, Cushendun, and Ballycastle. Both schemes aim to encourage the conservation of the natural and cultural heritage through grant-aid, environmental improvements and planning controls.

Historic monuments and buildings of special interest have been protected by scheduling and listing.[5] The Forest Service is promoting the recreational use of forests such as Ballypatrick, Glenariff and Glenarm. Larne Borough Council have developed a Country Park at Carnfunnock near Ballygalley. The National Trust own and manage properties at Fair Head, Murlough Bay and Cushendun.

Tourism will undoubtedly continue to be the area's mainstay service industry. It is somewhat ironic, however, that many past industries which now lend interest to the landscape would probably not have been permitted under the current system of pollution, health, safety and planning controls.

References

1. P. Magill, 1990, *Garron Tower, Co.Antrim* (privately published).
2. Bassett's book has been reprinted under the title *County Antrim One Hundred Years Ago* by Friar's Bush Press, 1989.
3. The character of early 20th century tourism is well captured W.A. Green's photographs, many of which are reprinted by C. Dallat, 1989, in *The Road to the Glens* (Belfast: Friar's Bush Press).
4. Department of the Environment (NI), 1988, *Antrim Coast and Glens AONB: Guide to Designation.* (Belfast: HMSO; reprinted 1991).
5. Department of the Environment (NI), 1988, *Antrim Coast and Glens AONB: Historic Monuments.* (Belfast: HMSO).

SITE GAZETTEER

This chapter details sites of industrial interest within the AONB. They are broadly arranged from north-west to south-east, as shown on the maps at the end of this chapter. Each heading shows the site's name (where known) and townland; its six-figure National Grid co-ordinate is shown in brackets; unless stated, this is assumed to be prefixed by 'D', the 100km grid square.

Ordnance Survey 1:50,000 map sheets 5 (Ballycastle) and 9 (Ballymena and Larne) cover the area.

Although some sites can be viewed from the public highway, most are on private property. The landowner's permission should always be sought if closer inspection is desired.

Care and common sense should be exercised when visiting sites. On no account should old mine adits or quarries be entered, however safe they might appear: they often contain hidden dangers, and rescue may put other lives at risk. Neither the author nor the Department of the Environment (NI) can be held responsible for any loss, damage or accident. Please also remember the Country Code: take your litter home, close gates after you, keep dogs on leads and leave sites as you would wish to find them.

More detailed information on specific sites may be obtained from the Archaeological Survey, Department of the Environment (NI), 5–33 Hill Street, Belfast BT1 2LA.

1. Coastguard Station, North St, Ballycastle (119414)

A prominent terrace of seven two-storey dwellings with central three-storey sandstone tower above the harbour. The latter has been heightened in brick when used as an anti-submarine lookout during World War I. The terrace superseded an earlier complex at the harbour (at 121414, now gone) around the mid-1800s. Still occupied. *Private.*

2. Marconi Memorial, Harbour Car Park, Ballycastle (120415)

Stone plaque commemorating the establishment of radio contact with Rathlin Island by Marchese

Coast guard station, Ballycastle. (AS)

Gugielmo Marconi and George Kemp in 1898. This was the world's first successful demonstration of communication across open water without the use of telegraph wires. The actual transmissions were made from White Lodge at the top of North St.

The car park is located in a former quarry from which basalt was obtained for Hugh Boyd's 18th century harbour.

3. Ballycastle Harbour (121415)

Boyd's 18th century harbour (4b) was superseded by a small quay alongside a slipway on a natural inlet just east of the present harbour car park. In 1891, McGildowney's Pier, a metal structure decked in wood, was erected to its west to service ferries to Ardrossan and Liverpool. In the 1930s, a concrete extension was added to the original quay, this being the main departure point for Rathlin Island.

McGildowney's Pier remained in use to around 1920, and was scrapped during the war; no trace now survives. The remaining pier was subject to heavy swells, making berthing difficult. To overcome this problem, a new concrete pier and slipway were erected immediately to its west in the 1980s.

4. Hugh Boyd's Ballycastle Industries

In the 1740s and '50s, the local entrepreneur and landlord Hugh Boyd set up a number of industries in an effort to develop a strong local market for coal from his nearby collieries. Although most of these endeavours were defunct by 1780, some traces survive.

(a) Manor House, Quay Rd (121411): Near the junction with Mary St. Boyd resided here from 1738 until his death in 1765. What remains of it is incorporated into a residential home. Some of his industries were housed in the adjacent buildings, the octagonal brick chimney being particularly prominent. *Private.*

(b) Harbour, Mary St (121413): The tennis courts and bowling greens occupy the inner basin of a harbour erected by Boyd in the later 1730s. To reduce silting, the Margy River was redirected to the east. Grant-aided by the Irish Parliament, Boyd's objective was to ship coal to Dublin. The import of various goods, such as rock salt to the nearby salt pans, was greatly facilitated, along with the export of local products such as glass, tanned skins, and kelp. The inner harbour fell into disuse after Boyd's death in 1765 and quickly became blocked with sand. It was superseded by a quay to the west (3). Most of the outer pier was washed away in the late 1880s, and what remained is now incorporated into a recent concrete construction.

(c) Glass Works, Glass Island (122412): Just above the shoreline, along the footpath to the wooden footbridge over Margy River. Rubblestone foundation of circular glass works established by Boyd in 1755. The conical brick flue was about 60ft in diameter, and stood upwards of 90ft high. Production ceased in the 1790s and the tower was demolished in the 1880s. Fragments of blue-coloured slag can be found in the stone wall along the adjacent recreation grounds.

(d) Holy Trinity Church, The Diamond (115407): Spired sandstone edifice erected at Boyd's expense and completed in 1756. Hugh Boyd was formerly buried inside. Some of the window glass is reputed to have been made at the glass works.

5. Commercial Ice House, Mary St, Ballycastle (121413)

Built into the north side of the former harbour basin (now tennis courts and bowling greens). Vaulted brick roof with two small ice charging holes but without entrance porch. Building in use as a tool shed.

6. Railway Station, off Ann St, Ballycastle (116407)

Located at the rear of the Ulsterbus Station, and now used by Road Service, Department of the Environment (NI). Erected by the Ballycastle Railway Co. in 1880, and operational until 1950. Although long closed, much still survives: plat-

form, one-storey station house/ waiting rooms, water tank, and cast-concrete engine shed. There was also an inclined siding down to a saw mill just west of the Tow Viaduct, in use between 1925 and 1940, and powered first by steam, then by water (the mill's steam boiler is now the station water tank).

7. Tow Railway Viaduct, off Fairhill St, Ballycastle (116406)

A four-arch bridge over the River Tow just below the former railway station. Erected by the Ballycastle Railway Co. in 1879/80. Of basalt construction with sandstone voussoirs and parapet stringing, all in excellent condition. A brickworks formerly operated just downstream, of which little survives. *Private.*

8. Footbridge, Glass Island, Ballycastle (122411)

Laminated-wood bridge at mouth of Margy River. The three horizontal spans are hung by steel cables from two towers set on concrete piers. Just upstream are the abutments and piers of a bridge erected in 1905 (to replace an 1893 bridge), which facilitated access to golf course. *Ulster Way.*

9. Bonamargy Bridge, Cushendall Rd, Ballycastle (123409)

Built around 1860 to replace one erected in the 1830s as part of the Larne-Ballycastle Road, but washed away in 1857. Of dressed sandstone, its three slightly skewed segmental arches carry the road over the Glenshesk River.

10. Drumahaman Bridge, Bonamargy (126406)

Carries the Ballycastle-Armoy road over the Glenshesk River. Three of its four segmental rubble-stone arches are in use, the fourth being a flood arch. The bridge has string courses in dressed basalt, and voussoirs (arch edges) highlighted in sandstone.

11. Salt Pan, Broughanlea (135415)

Immediately north of the coastal road, east of a group of houses at 'Pans Rock'. Partially buried remains of a large riveted sheet-metal pan with adjacent tip of coal ash from furnace. Only excavation can reveal whether it is in its original position. Seemingly in use until 1820s. A rock-cut chamber on the nearby rocks may be associated with the collection of seawater. *Private.*

12. Ballycastle Collieries

Over a dozen coal mines were worked between Pans Rock and Carrickmore from the 1600s onwards. Their heyday was in the mid-1700s, under the auspices of Hugh Boyd. Of the many workings, two adits can still be found along the surfaced coast road. Beyond the car park at the end of the road, a rough path continues above the shoreline, past a number of grass-covered spoil heaps and small exposures of friable coal along the cliff face. *On no account should any adit be entered, and all are on private property.*

(a) White Mine, Broughanlea (138415): On the south side of the road, near a sharp bend. In use from the 1730s to the present century, one adit is still visible at the back of an earlier quarry.

(b) North Star Colliery, Tornaroan (148419): Open roadside adit, some 5ft wide by 6–9ft high, near the North Star Dyke. The entrance is arched in dressed stone, the soffit extending some 50yds into the mine. The coal was worked in levels above the access adit, with interconnection by vertical shafts. The adit is partly flooded and is blocked by a roof collapse.

North Star colliery, Ballycastle.

13. Carrickmore Ironstone Mines and Jetties

Blackband ironstone (iron carbonate) was mined in the Carrickmore area in the later 1800s. The ore was burnt to convert it to iron oxide which was then exported to Scottish iron works.

(a) Extensive terraces of spoil and calcine waste line the shore below the cliffs (166428)

(b) A short length of revetment of the former Carrickmore Jetty survives at grid 164427. From it ran an iron pier from which the ore was shipped.

(c) Ore was also shipped from Ballyvoy Jetty (154421), just beyond the end of the surfaced road. The stumps of the legs of the metal superstructure are still evident on a dyke extending from a stone revetment.

14. Colliers' Row, Ballyreagh Lower (163407)

A one-storey terrace of back-to-back houses erected in the 1860s by the Ballycastle Iron Mining Co. to house employees at their nearby Carrickmore ironstone mines. The name also suggests use by coal miners. Several of the houses at the north end have been refurbished, although most lie empty. *Private.*

15. Murlough Bay Collieries

Mined sporadically from at least the early 1800s to the present century. *National Trust.*

(a) At the foot of a cliff west of a track leading north from the upper car park, a substantial spoil heap is clearly evident (at 190427). It leads to a now-flooded horizontal adit some 5ft high by 4½ft wide.

(b) Towards the shore, at the very north end of the track is the 'Arched Mine' (188431), recognizable by the twin arched entrances (*do not enter*). Other spoil heaps are evident hereabouts, although land slippage has obscured their associated adits.

(c) South-east of the Arched Mine are the ruins of a terrace of four cottages said to be miners' houses (190430). The coal was shipped, apparently with some difficulty, from the adjacent 'Stage Rock'.

16. Lime Kiln, Bighouse (189417)

Rubble-stone kiln to west of road to Murlough Bay, beside small limestone quarry. With its single charging and draw holes, it is typical of many such kilns in the region. *National Trust.*

17. Ballyvoy Bridge, Ballyvoy (158403)

This single segmental arched bridge, of dressed sandstone, carries the main Cushendun-Ballycastle road over the Carey River.

18. Corn Mill, Coolnagoppoge (176394)

Off the Cushendun Road, three miles east of Ballycastle. The building is probably of early 19th century date, with later replacement machinery. A pitchback waterwheel, 12ft by 2ft 2in drives a pair of 4½ ft diameter millstones via single-step cast-iron gearing. Complete with ancillary sieves, fans and sackhoist. Ruined kiln and miller's house adjacent. Worked to 1940s. *Private.*

On the left bank of the river to the north, near the bridge, are the remains of corn and flax mills (173397).

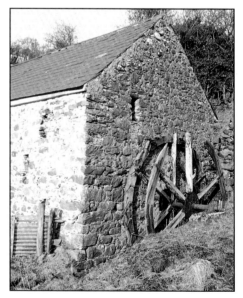

Coolnagoppoge cornmill. The water fed to the wheel from the right-hand side.

19. Commercial Ice House, East Torr (229402)

On the road leading down to Torr Head. Porched rectangular building cut into a north-east facing hillside, with ice charging hole at apex of west gable. Now used as a store. A small harbour (now refurbished) associated with the fishery lies nearby (233403). *Private.*

20. Torr Head Coastguard Station, East Torr (234405)

Coastguard station prominently situated on the headland. Dating to the earlier 1800s, it also acted as a Lloyd's Signal Station for North Channel shipping. Under the headland, on its landward side (at 231403), are the ruinous remains of a later 19th century terrace of two-storey dwellings, abandoned when gutted by fire during the Troubles of 1920. *Private.*

21. Railway Tunnel, Cape Castle (087367)

Built by the Ballycastle Railway Co. in 1879/80. Just north of Cape Castle Station (of which only the platform remains, the wooden waiting room having been cleared), this 100yd tunnel conveyed the single-line track under a section of road and hillside. It survives in good condition, with dressed-masonry arches at either end. Why it was necessary to go to such lengths when a cutting would have sufficed is unclear. *Private.*

22. Limestone Quarry, Toberbilly (101365)

Large limestone quarry on west slope of Knocklayd. In use from at least the 1830s, but abandoned several decades ago. A number of dilapidated buildings, including lime kilns, and extensive spoil heaps survive. It is best viewed from the main Armoy-Ballycastle road. *Private.*

23. Glenshesk Bridge, Clare Mountain (141357)

Erected sometime between the mid 1830s and '50s, Glenshesk Bridge carries a realignment of the Ballycastle-Armoy road high over the Glenshesk River. The voussoirs, string courses and abutment quoins of the dressed-basalt semi-circular span are highlighted in sandstone.

24. Old Cushendun-Ballycastle Roads

Two old roads run either side of the 1830s' Cushendun-Ballycastle Road.

(a) That to the north, over the western flanks of Cushleake and Carnanmore Mountains (between 155407 and 237324) is depicted on 1832 O.S. 6" map, running between Cushendun and Ballyvoy. Surfaced single track still in use between Ballyvoy and Hungry House, thereafter running as a track towards Cushendun. The *Ulster Way* follows its route.

(b) That to the south, on the eastern flanks of Crockanell and Carneighaneigh Mountains (between 155407 and 226321) runs as a single track between Cushendun and Ballyvoy, and is depicted on 1832 6" map. Can still be followed as an unsurfaced road. A short metalled section at its south end, between Knocknacrow and Clady Bridges, is still in use despite its steepness.

25. Bridges on the Cushendun-Ballycastle section of the New Coast Road.

The road in the vicinity of Ballypatrick Forest crosses a number of streams, over which a number of bridges were erected.

(a) Altadreen Bridge, Ballypatrick (188379): Semi-circular single-span basalt bridge with sandstone voussoirs and string coursing. Inscribed plaque on parapet reads 'AVLTADREEN 1834'.

(b) Bushburn Bridge, Ballypatrick (195369): Similar to Altadreen Bridge. Inscribed parapet plaque reads 'BVSH BVRN 1834'.

(c) Altheela Bridge, Ballypatrick (196366): Similar to Altadreen Bridge. Inscribed plaque reads 'AVLTHEELA 1834'.

(d) Corratavey Bridge, Ballypatrick (199362): Of similar construction to Altadreen Bridge, although considerably higher. The stream bed, here paved with hexagonal stones similar to those from the Giant's Causeway, is also shared by a forest track. Inscribed parapet plaque reads 'CORETAVY VILLIAM BALD ENGINEER'. Best seen from below, and accessible via the Forest Drive, or down a rough path west of the main road.

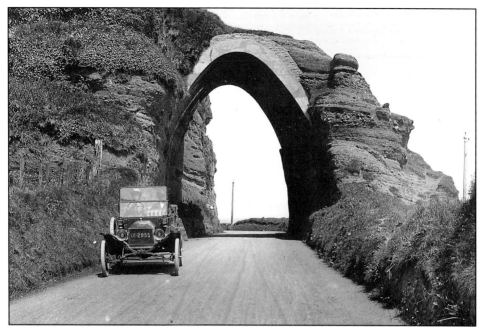

Red Bay arch, early 1900s. (UFTM: WAG 1438)

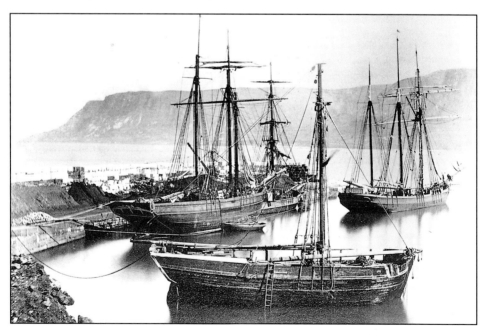

Red Bay harbour, c.1870. Limestone and iron ore await shipment (UFTM: Holden L378/5)

(e) Craigacat Bridge, Grange of Inispollan Mountain (222339): Single segmental skew span in partly-coursed stone. An almost illegible inscription on the downstream parapet reads 'CRAIGACAT 1834'.

26. Glendun Viaduct, Clegnagh (216321)

Designed by Charles Lanyon and completed in 1839 as part of the Coast Road scheme. Eighty feet high, it carries the main Cushendall-Ballycastle road over the Glendun River. This new line of road, contouring gradually up and around the hillside, largely superseded earlier roads (24) which climbed steeply out of the glen from Clady Bridge a short distance downstream.

The bridge comprises a large central semi-circular arch flanked on either side by two smaller arches, all in dressed sandstone with highlighted pier quoins, voussoirs and parapet stringing. The river runs under the central arch, and a road up Glendun from Cushendun passes through the north arch. An inscribed sandstone plaque on the downstream parapet reads 'GLEN DUN BRIDGE 1839'.

27. Corn and Flax Mills, White House (241327)

Half a mile west of Cushendun, on left bank of Glendun River. Corn mill erected by James White in 1847 (the 1812 datestone above the door is probably from an earlier mill). Internal waterwheel 16ft by 8ft 3in powers three sets of millstones set in a lineshaft arrangement of cast-iron gearing. Retains all ancillary machinery. Worked until the 1950s. Flax mill adjoins on west side, erected in early 1900s, and driven off same wheel. Although now roofless, four sets of six-bladed handles and a roller (by McAdam, Currel & Co, Belfast) survive. *Private.*

28. Cushendun Bridge, Cushendun (249326)

Four segmental arches of dressed sandstone carry the main Coast Road over the Glendun River. Probably erected in 1830s as part of New Coast Road project. Subsequently widened on both sides with cantilevered footpaths, but with retention of sandstone parapets.

29. Water Reservoir, Turnly's Tower, Cushendall (237276)

Also known as the Curfew Tower. Erected by Francis Turnly in the centre of the village in 1821. At a later date, a spring-fed reservoir was built into the ground floor. This supplied a now-defunct fountain on the tower's east wall, inscribed with the initials F, S, J and T.

30. Cushendall Bridge (238276)

Two segmental arches of dressed sandstone carry the main Coast Road over the Dall River.

31. Red Arch, Red Bay (244261)

Parabolic arch cut through sandstone headland at Red Bay by Francis Turnly in 1817 to improve the Old Coast Road between Waterfoot and Cushendall. Prior to this it was necessary to negotiate a steep and narrow track up to the higher ground to the west. The arch, some 35ft high by 25ft long, continues in use, the soffit being lined with concrete.

32. Red Bay Pier (244260)

Erected in 1849 to serve Cushendall and Waterfoot. The bulk of its trade was in iron ore from the Cargan district. For a brief period in the early 1870s, the pier was connected by an aerial ropeway to the Glenravel mines. The construction of the Ballymena-Retreat railway in 1876, and its linking with the Larne line in 1880, caused trade to decline.

The basalt pier is now refurbished with the addition of a reinforced concrete pier and breakwater. Between 1970 and 1973, Western Ferries operated a car/passenger ferry to Kintyre.

33. Waterfoot Bridge, Foriff (239255)

Twin-arch bridge carries the Coast Road over Glenariff River. Of rubble-stone construction, unlike most other bridges along the Road, which are of dressed stone. Pedestrian footbridge to north.

34. Wind-powered Electricity Generator, Corkey South (104228)

On a north-west spur of Slievenahanaghan, just south of the road. Recently erected by the Northern Ireland Electricity Service as an experimental wind generator. The 80ft high tower is surmounted by a 75ft diameter twin-bladed rotor linked to a generator rated at 400 horse power. *Private.*

35. Corn Mill, Skerry East (145173)

On right bank of Skerry Water beside the iron smelter, south of Newtown Crommelin. Erected by Nicholas Crommelin in 1820s as part of his ill-fated attempt to lure settlers to his newly established village. Originally with a 24½ft diameter by 5ft wide waterwheel, only part of the gutted shell survives. *Private.*

36. Iron Ore and Bauxite Mines, Cargan District

In the 1870s and '80s, the mountainous slopes around Cargan were Ireland's largest producer of iron ore, mining having commenced in the 1860s, and continuing into the 1920s. Bauxite was also mined from the 1880s through to the 1930s, and again during the Second World War. Remains of spoil heaps and old mineral railways abound, and in several instances horizontal mine adits. *Although open moorland, the land is private (unless otherwise stated), and permission should be sought before venturing forth; on no account should open adits be entered.*

(a) Trostan Mines, Barard (between 194227 and 175246): The scarp around the east and north slopes of Trostan Mountain was worked by the Antrim Iron Ore Co. for iron ore in the 1870s, and again for bauxite in the 1890s. Over 20 heaps, of varying size, are still visible, a large conical tip a the south end of the workings being particularly prominent. Served by the Trostan Tramway (38a).

(b) Essathohan Mines, Parkmore (between 187216 and 193224): Extending along the west side of the Ballymena-Cushendall road north of Essathohan Bridge, this tract was leased to the Parkmore Iron Co. in 1870, re-leased to the Antrim Iron Ore Co. in 1882, and finally worked by the Crommelin Mining Co. in 1930. Initially iron ore was mined, but this was increasingly replaced by bauxite. Operations ceased in 1934. It was serviced by the Retreat Railway (37). Although the area is now under trees, a number of spoil heaps and adits are still evident. *Forest Service.*

(c) Parkmore Mines, Parkmore (between 185205 and 186214): Mining tract running for almost 3/4ml along the west side of the Ballymena-Cushendall road north of the former Parkmore Station. Worked by the Parkmore Iron Co. from 1870 to 1876. In 1882 re-leased to the Antrim Iron Ore Co. which continued operations until 1923. Average output was generally in excess of 10,000 tons of iron ore per year; bauxite was increasingly mined in later years. Serviced by the Retreat Railway (37).

Although the area is now afforested, extensive remains are still discernible. South of the track to Skerry East are several spoil heaps and adits (at 185205). North of the track are the stone foundations of an explosives magazine (at 185207), north again of which are several spoil heaps and adits. The fire break between the magazine and spoil heaps appears to have been an embanked access track. To the north are yet more spoil heaps and adits. On the opposite side of the road a terrace of mine workers' houses formerly stood, now now demolished (186205). *Forest Service.*

(d) Evishacrow Mines, Evishacrow (173189): A number of spoil heaps around the southern flanks of Binvore Hill indicate iron ore and bauxite mining from about 1870 to the mid-1920s, first by the Evishacrow Mining Co, and then by the Crommelin Mining Co. Good exposures of red laterite and grey bauxite are visible. The mines were served by the Evishacrow Siding (38c).

(e) Glenravel Mines, Legagrane (between 159194 and 171197): The largest and earliest of the Mid-Antrim mines, having been established by James Fisher in 1866. The three-quarters of a mile long scarp on the southern slope of Slievenanee was worked by James Fisher & Sons until 1913. Ore production averaged some 15,000 tons per year (two lorry loads per day in today's terms),

peaking at 43,000 tons in 1880. The mines were served by the Parkmore Siding (38b).

Extensive remains of open cast mining and spoil heaps are everywhere apparent. More recent stone quarrying operations have exposed adits at 163195 and 170197, both now blocked.

(f) Crommelin Mines, Skerry East: A series of iron ore and bauxite mines are to be found along the south-west and west slopes of Slievenanee, above the Skerry Water. Worked by the Crommelin Mining Co. from the later 1880s to 1930s, and serviced by the Crommelin Siding (38d). From north to south, the mines are:

i Herd's Drift (150205): Extensive spoil heaps of former iron ore mine close to the river west of the laneway. To their east is an infilled adit entrance and several air vents, also blocked.

ii Spittal's Drift (150200): Adjacent to the laneway, extensive spoil heaps of former iron ore mine survive, in part quarried away for road material. To the north, a gully leads to a now-blocked adit immediately below the track.

iii Salmon's Drift (151198): Spoil heap and adit of former iron ore and bauxite mine still visible to east of laneway.

iv Walker's Drift (152195): East of the laneway. Spoil heaps of former iron ore mine evident on either side of a recently-made track.

v Crommelin Mine (154192): Spoil heap and infilled adit entrance of former iron ore mine visible.

vi Tuftarney Mine (158192): Substantial spoil heap now cut through by a recent track. A stone revetment runs along the south side of the heap, from which the ore was discharged from the mine hutches into the railway wagons.

(g) Bauxite Mines, Skerry East (between 140187 and 140184): Substantial terraces of spoil heaps on the hillside to the west of the road north from Newtown Crommelin are all that remain of bauxite workings dating to 1941–44. One of the adits has been tapped for a water supply.

(h) Cargan Mines, Cargan (168179): Worked by the Antrim Iron Ore Co. from 1872. The Crommelin Mining Co. took over operations in 1897, primarily working the bauxite until closure in 1908. Served by the Cargan Siding (38e). Spoil heaps are still evident.

(i) Dungonnell Mines, Dungonnell (179171): On the north side of the Ballsallagh Water. Leased to the Antrim Iron Ore Co. in 1872, but abandoned in 1891 owing to legal wrangles. Serviced by the Cargan Siding (38e). Three spoil heaps and one adit remain. There were also adits to the east (at 185172), now blocked.

(j) Binvore Cottage, Evishacrow (167188): Site recognizable by presence of evergreen trees. Ruinous remains of former dwelling of Edward Benn, the local landowner who granted iron ore mining rights to James Fisher in the 1860s. A sandstone plaque on the south-west corner of the eastern building reads 'E. Benn 1836'. Benn subsequently moved to Glenravel House half a mile south of Cargan (at 163171).

(k) Iron ore smelter, Skerry East (145173): Furnace erected in the 1840s by Nicholas Crommelin on the right bank of the Skerry Water just below Newtown Crommelin. Smelting trials proved unsuccessful and the furnace was soon abandoned. The basalt structure, measuring 18'3" square by about 20ft high, survives substantially intact. Small access holes at the base of its north, east and south walls, lead into a 5ft square firing chamber.

Iron ore smelter, Newtown Crommelin. The remains of the cornmill are also visible in the background.

37. Ballymena, Cushendall & Red Bay Railway

Narrow-gauge mineral railway opened in 1876 between Ballymena and Retreat, via the Glenravel valley and Cargan, a distance of 16½mls. Passenger services instigated to Parkmore in 1880s, running to 1930. Goods traffic ceased in 1937/40. Has the distinction of having been the highest railway in Ireland, rising to 1045ft near Parkmore.

The line can be followed over much of its course within the AONB, being prominent along the roadside between Cargan and Parkmore, and from the edge of Parkmore Forest to Retreat. A particularly fine stretch of embanking can be followed in the woodland south-west of Essathohan Bridge (vicinity of 188214). The station master's house at Cargan, opened in 1888, has been refurbished beyond recognition (it stands beside a petrol station at 165080). Of more interest are the numerous sidings (38), Retreat Terminus, Essathohan Bridge and Parkmore Station.

(a) Retreat Terminus, Retreat (204241): Immediately south-west of Retreat Castle, on the slopes of Crockalough. Operational between 1876 and 1937. There is little now to see beyond a two-storey dwelling house (now in disrepair), and loading platform, the goods store and crane having gone. However, the silent moorland is full of atmosphere, and is particularly melancholy on a rainy day. Hereabouts the line follows an older roadway (marked on the 1832 map), which can be followed several hundred yards north-east of the station. The steep gradients of Glenballyemon, which caused construction of the line to be abandoned here, are clearly evident. *Private.*

(b) Essathohan Bridge, Parkmore (191217): A substantially intact single arch bridge over the Essathohan Burn, immediately east of the road bridge. One of the few segmental arched bridges (with voussoirs highlighted in brick) along the line, most being of simple girder construction on basalt abutments.

(c) Parkmore Station, Parkmore (186201): Lying just west of the Cushendall/Waterfoot road junction, this station was opened in 1888 as the terminus for tourist traffic to Glenariff. The origi-

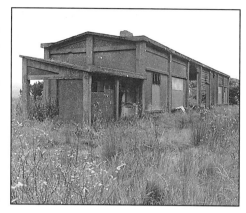

Railway station, Parkmore.

nal waiting room was destroyed during the Troubles of 1921, being replaced by the surviving pre-cast reinforced-concrete structure. Along with several other buildings along this line (but outside the AONB), it is one of the earliest pre-cast structures to survive on Irish railways. The use of this material was pioneered by the Midland Railway (Northern Counties Committee), who took over the line's running from the Belfast & Northern Counties Railway in 1903. The building was used for a time as a Youth Hostel, but is now derelict.

A short distance north (at 186202) is a large metal water tank (by James Moore, Belfast, 1906) supported on brick piers. This serviced the steam engines; some pumping equipment survives inside. The station master's house which stood hereabouts has been reduced to a pile of brick rubble. *Forest Service.*

38. Mineral Sidings, Cargan District

In the later 1800s, a network of mineral railways and tramways serviced the iron ore and bauxite mines around Cargan. *All are on private property.*

(a) Trostan Siding (between 195225 and 179243): This three-quarter mile long tramway, constructed in 1872, linked the Trostan mines (36a) with the roadway. The ore was then carted to Red Bay. With the construction of the Retreat

Railway in 1876, the ore would have been shipped to Ballymena; however, there is no evidence that the tramway and railway were ever physically linked. Climbing to 1400ft, this was the highest of the Antrim tramways. Following the spoil heaps around the hillside, it is still quite visible today, with a prominent cutting along its middle section.

(b) Parkmore Siding (between 186199 and 159193): Horse-drawn tramway constructed in the 1860s by James Fisher to link the Glenravel mines (36e) with the Ballymena Road near the Parkmore/Waterfoot junction. From here the ore was carted to Red Bay Pier; with the opening of the Retreat line in 1876, it was trans-shipped to mainline wagons at Parkmore Station.

The course of the 2½ft gauge track can still be followed along its two mile length, and is particularly impressive along the scarpfoot of the Glenravel mines. Across the Binvore Burn are the remains of a single-arch bridge (at 171197), the decking of which was (at the time of survey) supported by uncut tree trunks. Although these timbers are of no great antiquity, the original bridge was probably likewise constructed.

(c) Evishacrow Siding (between 175187 and 171196): this one mile long siding served both the Evishacrow (36d) and Ballynahavla mines (the latter at 171196, but now with few remaining traces). The line's course is still quite visible around the south and west slopes of Binvore Hill.

(d) Crommelin Siding (between 165180 and 150203): A two mile siding serviced the Crommelin Mining Company's mines above the Skerry Water (36f). The Cargan-Tuftarney stretch is most evident, embanked across the valley of the Cargan Water (vicinity of 165183)

Of special note is an inclined plane just north of the river (at 164186). Locally known as the 'Drum Brae' it conveyed the ore waggons down a 1-in-10 slope, the full wagons raising the empty ones up a parallel track. It is some 300yds long by 15ft wide, embanked towards its upper end, and with progressively deeper incutting towards the bottom. The remains of winding drum piers are at its top end.

A quarter of a mile further along, just north of the track to Newtown Crommelin (at 159192), are the ruinous walls of a structure cited as an engine and chimney on the 1857 O.S. 6" map. This implies a steam engine, although a mine map indicates an loco shed here, suggesting the siding may have been a railway, rather than horse tramway.

(e) Cargan Siding (between 166181 and 184172): Both the Cargan (36h) and Dungonnell Mines (36i) were served by the Cargan Siding. This ran from just above Cargan Station along the north banks of the Ballsallagh Water to the upper Dungonnell mine. Its one and three-quarter mile course is now only evident where embanked and incut, as in the vicinity of the lower Dungonnell mine (179171).

39. Distillery, Legagrane (165186)

Enigmatic ruins of rubble-stone buildings on left bank of Binvore Burn, half a mile north of Cargan. Established by the local landowner Edward Benn sometime between the later 1830s and mid 1850s to distill alcohol from potatoes. Ruinous by 1857.

The adjacent stream would have ensured a steady supply of water both for the product, and for cooling during distillation. Whether it was also harnessed for motive power is unclear, as there is no positive indication of a millrace.

Given the availability of water throughout the area, the choice of this remote site is something of a mystery; possibly it was an ill-fated attempt to evade the Excise Authorities. *Private.*

40. Callisnagh Bridge, Baraghilly (224214)

Carries the old Glenariff-Ballymena Road over the Glenariff River. A single-arch rubble-stone span with humpback deck and zig-zag approach, typical of many 18th century bridges. Compare its construction with the mid-19th century single-span Altahuggy Bridge to its west, on the new line of road on the other side of the valley (at 219211).

41. Glenariff Iron Ore Mines, Cloghcor (between 213194 and 217198)

On the south-east side of the Inver Water, in the upper reaches of Glenariff, these mines were worked by the Glenariff Iron Ore & Harbour Co. from 1873 to early 1880s, when forced to close due to uneconomic mining methods. Several workings were also opened in the 1870s along the west slopes of the gorge. Serviced by the Glenariff Mineral Railway (42).

A series of substantial spoil heaps are still evident along the top edge of the tree line at 700ft altitude; all the adits are now blocked. On the east side of the Inver Water, a spoil heap is visible just above the footpath (at 211193). The sites are best approached along the track from the Forest Park Visitors' Centre. *Forest Service.*

42. Glenariff Mineral Railway (between 211193 and 259250)

Constructed by the Glenariff Iron Ore & Harbour Co. in 1873. Contouring along the south side of Glenariff, it linked their Cloghcor iron ore mines at the valley head with a purpose-built pier near Milltown, from whence the ore was shipped to Britain. At 3ft gauge, this six mile track has the distinction of being the first narrow-gauge railway in Ireland. The uppermost part of the track ends in a series of switchbacks (now firebreaks through the forest) up to the line of mines at 700ft altitude; there was also a spur to the west side of the Inver Water. With the closure of the mines in the 1880s, the railway ceased to function.

The course of the railway is still clearly visible along its middle and upper reaches. Notable features include Milltown Pier, White Arch Bridge, Engine Shed and Greenaghan Viaduct. It is seen to best advantage from the opposite side of the valley.

(a) Milltown Pier, Carrivemurphy (259250): Erected to ship iron ore from the Glenariff mines to iron furnaces in Cumbria and Scotland. In 1901, a large portion was washed away in a storm, and now only fragments remain out to sea.

(b) White Arch Bridge, Carrivemurphy (256248): Carried the mineral railway over the Coast Road to the pier. Only the dressed limestone abutments of this girder-arch bridge remain, that on the seaward side with an ornamental arch.

(c) Engine Shed, Carrivemurphy (255247): Behind the terrace of houses, this former locomotive shed has now been refurbished and incorporated into a larger recreation hall. *Private.*

(d) Greenaghan Viaduct, Greenaghan (236227): Carried the mineral railway over the Altmore Burn, which has here carved a deep gorge into the hillside. Although the girder spans have long since been lifted, their four tapered limestone piers remain. This is the most spectacular bridge along the line, the other streams merely being culverted. *Private.*

43. Mine Workers' Houses, Carrivemurphy (254247)

Terrace of 14 two-storey dressed-limestone mine and railway workers' dwellings erected by the Glenariff Iron Ore & Harbour Co. in the 1870s. Still in use, and known as 'Seaview Terrace'. *Private.*

44. Iron Ore Mines, Garron Plateau

In the 1870s, a number of trials were made, and at least one mine worked by the Antrim Iron Ore Co. along the interbasaltic scarp between Garron Point and Red Bay. Prominent survivals include the Ardclinis and Carrivemurphy workings, Fallowvee Pier and an inclined plane. *All sites are on private property.*

(a) Ardclinis Mine, Ardclinis (273240): Several adits are recorded along the right bank of the Ardclinis Burn, but only one is now open, immediately below a waterfall at an altitude of 850ft. The ore was dispatched to the pier at Fallowvee down an inclined plane to the north. Best approached along the track to the west of the gorge.

(b) Carrivemurphy Trial Adit, Carrivemurphy (267240): An opening is clearly visible in the red

Left: Iron ore mine, Ardclinis. The adit entrance is at the foot of the waterfall, on the left. (AS)

Top: Turnly's Cut, Garron Point. (AS)

interbasaltic bed at the head of the Cushenilt Burn. Approximately 5ft high by 4½ft wide, it runs for a distance of 25–30ft, at which point it was abandoned. Relatively inaccessible, it is best approached up the track (partly stone paved) on the left bank of the stream.

(c) Inclined Plane, Ardclinis (between 269248 and 270245): Known locally as 'The Drum', it served the Ardclinis Mine. Its quarter mile course, in places embanked and incut, climbed 500ft directly up the face of the steep basalt escarpment. Nothing survives of the gravity-powered plant.

(d) Fallowvee Pier, Fallowvee (283254): A small length of dressed limestone quay is all that remains of the former pier built in the 1870s and washed away during a storm in 1901.

45. Ardclinis Bridge, Ardclinis (270250)

A single-arch dressed basalt bridge, with decorative sandstone voussoirs, parapet string course and coping, erected in 1830s to carry the Coast Road over the Ardclinis Burn. Superseded a twin-arch rubble stone bridge immediately downstream (at 270250).

46. Old Coast Road, Galboly Lower

Several road features survive hereabouts which pre-date the New Coast Road.

(a) Turnly's Cut (300243): Also known as 'Split Rock', this 60ft deep by 15ft wide cutting through a chalk headland was made by Francis Turnly in 1822 as part of a road improvement scheme between his house at Drumnasole (near Carnlough) and lands at Cushendall. The road continues to the north, meeting the coast at the White Lady Rock.

(b) Foaran Path Incline (301244): The former course of Old Coast Road ran through what later became Garron Tower (now St.MacNissi's College). Here it descended steeply to the road, and is still clearly visible as a green lane. A two/three-storey house stands nearby, just south of the White Lady (305249), where horses were stabled to assist coaches up the incline. *Private.*

47. Water Pump, Galboly Lower (301244)

On the Coast Road just north of Garron Point. Pump erected in 1854 to raise water to reservoirs in the grounds of Garron Tower, a residence of the Londonderrys (now St.MacNissi's College). A dressed-basalt pump-house (with mullioned dummy window on the seaward side) houses a triple-throw pump, chain driven off a 12ft diameter by $2\frac{1}{2}$ft wide all-metal high-breastshot waterwheel. The supply stream is reputedly the shortest river in Ireland, at 130yds. Now superseded by nearby electric pumps. *Private.*

48. Domestic Ice House, Galboly Lower (301240)

Cut into the north face of Dunmaul Motte, in the grounds of St.MacNissi's College. Erected in the 1850s to service Garron Tower. A brick-lined chamber of rectangular cross-section and overall height of 12ft 3in, but without ante-passage. *Private.*

49. Coastguard Houses, Galboly Lower (302238)

Roadside terrace of cottages, in dressed basalt, formerly associated with the lookout station perched on Garron Point (at 301240, of which only the basal walls survive), and quay to the south (302237). Largely unaltered, the cottages are still in use as dwellings. *Private.*

50. Newtown Bridge, Newtown (297217)

Erected in 1830s, a dressed-limestone single-span bridge over minor stream. Voussoirs highlighted in sandstone.

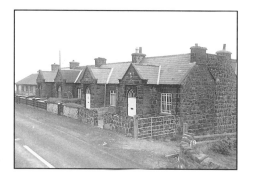

Coastguard houses, Garron Point. (AS)

51. Old Coast Road, Burnside (between 293212 and 293217)

Six hundred yard section of unsurfaced road, now abandoned, through Drumnasole Estate immediately north of Broken Bridge. *Private.*

52. Road Bridge, Burnside (296210)

Erected over the Black Burn in the 1830s. Single segmental arch in dressed basalt, with sandstone voussoirs, string course and parapet coping.

53. Road Bridge, Highlandtown (293201)

Erected in 1830s. Single dressed-basalt span over stream and access lane to beach. With sandstone voussoirs and string course.

54. Lime Kiln, Lemnalary (286198)

Single-hole kiln of dressed limestone, set into hillside. Visible from Coast Road. *Private*

55. Sulphate of Ammonia Works, near Carnlough

From 1902–08, peat was dug on the moorlands above Carnlough, being dispatched on an aerial ropeway two miles down the Cranny Water to a processing plant where converted into ammonium sulphate fertilizer.

(a) High Station, Aghalum (248174): on desolate moorland, 30 minutes walk from the nearest road. A large rubble-basalt building houses the workers' canteen and quarters. The peat was dispatched to the 'Low Station' on an aerial ropeway, basal remains of which survive hereabouts. *Private.*

(b) Low Station, Carnlough South (275185): Here the peat was processed. Scattered concrete foundations are all that remain, along with a wooden chalet (formerly the manager's house, and subsequently a youth hostel) and large water tank (formerly with a wind pump). Several of the buildings were re-erected at a farm near Buckna (at 206087). Visible from Ulster Way. *Private.*

56. Limestone Quarries, Gortin and Creggan (between 273186 and 280190)

Prominent above Carnlough, quarrying began in the 1700s. Initially the stone was conveyed to the roadhead on an inclined plane ('hurry'), but this was superseded by a mineral railway (57) in 1854. Worked by the Eglinton Limestone Co. until the 1960s, extensive faces, several hundred feet high, run for almost a mile along the hillside. Visible from Coast Road and Ulster Way. *Private.*

57. Mineral Railway, Carnlough South (between 288180 and 276186)

A cable-operated 4ft 8¹/₂in gauge line, some 1500yds long, ran from Gortin Limestone Quarry to Carnlough Harbour (59), serving kilns and a whiting mill en route. Built by the Londonderrys in 1854, it comprises an embanked and incut inclined plane. Dressed eliptically-arched limestone bridges carried the track over High Street and Shore Street (both in the vicinity of 287180); the latter bears an inscribed sandstone plaque commemorating its erection. From 1952, until closure in the mid-1960s, the line was electrically operated; at the harbour end a tractor was used to move the wagons. From 1890 onwards, a 3¹/₂ft gauge line from Tullyoughter Quarry (61) ran parallel to this line as it approached the harbour.

The *Ulster Way* follows the lower section of the line from the harbour to the site of the former kilns.

58. Lime Kiln, High St, Carnlough (286181)

Erected in 1855 beside mineral railway, just west of High St. A rubble-basalt base supports a dressed limestone superstructure surmounted by a tapered brick flue. Superseded by larger kilns to the west (at 282183, but now gone) in the 1860s. *Private.*

59. Carnlough Harbour (288180)

Erected by the Londonderrys in the mid-1850s for the export of limestone, superseding one erected by Philip Gibbons in the 1790s. A plaque commemorating its opening in 1855 can be seen in the nearby Londonderry Arms Hotel. Mineral railways linked with the Gortin and Creggan Quarries to the west, and Tullyoughter Quarry to the south, the line running along the harbour wall, thus permitting direct discharge into the waiting boats. 'Harbour House', the former offices of the limestone works, is at the railway bridge end of the complex, and is now refurbished as a dwelling. Unlike Glenarm Harbour, Carnlough can be used at all states of the tide. It has recently been refurbished as a recreational amenity.

The cast-iron structure on the harbour's south wall, here widened to accommodate the limestone wagons, is the beacon from an old lighthouse at Ferris Point on Island Magee.

At the north end of the harbour, beside the road, is a small rectangluar boat house of rubble basalt and chalk construction, with refurbished metal roof. This was formerly a store for kelp, gathered along the coast herabouts, and shipped to Britain.

60. Glencloy Bridge, Bay (288168)

Erected in 1830s, a twin arched bridge of dressed limestone, with sandstone string course, voussoirs and parapet coping.

61. Tullyoughter Quarry, Ballyvaddy (283153)

Large scale quarrying began in the 1890s when this early 19th century quarry was linked by a mineral railway (62) to a whiting mill (at 285180, now gone) and the harbour at Carnlough. The quarry was worked by the Eglinton Limestone Co, closing in 1922.

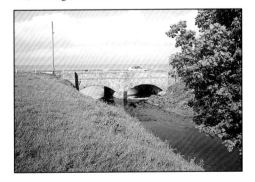

Glencloy Bridge, Carnlough.

The abandoned working face is clearly evident over its quarter mile length, along with sizable spoil tips. Two parallel terraces of one-storey quarry workers' houses, known as 'Tullyoughter Row' survive near the river (at 283155). Erected in the 1890s, each terrace comprises five now-roofless dwellings. Best viewed from the road on the opposite side of the valley. *Private.*

62. Mineral Railway, Bay (between 288180 and 283153)

Just over two miles long, this 3½ft gauge track conveyed limestone from Tullyoughter Quarry to Carnlough Harbour between 1890 and 1922. The line was dismantled in 1924. However, the partly embanked line is still evident in the vicinity of the quarry and north of the Glencloy River. Substantial remains of a single-arch girder bridge also survive (284156). *Private.*

63. Coastguard Station, Parishagh, Glenarm (306157)

A terrace of two-storey houses just north of Glenarm. Of later 19th century date, now refurbished as dwellings. *Private.*

64. Limestone Quarry and Kilns, Demesne Upper, Glenarm (304150)

Extensive quarry worked since early 1800s, and still operated by Eglinton Limestone Co. Along the road to south (at 304149) are four large contiguous kilns, in dressed limestone with brick-lined draw holes. *Private.*

65. Barbican Bridge, Glenarm (310151)

Twin segmental arch bridge in rubble-stone over Glenarm River, probably of 18th century date.

66. Glenarm Bridge, Cloney (311153)

Triple segmental arched bridge in dressed basalt erected in 1823 to carry Coast Road over Glenarm River. Widened in 1921 with the addition of cantilevered concrete footpaths; parapets rebuilt in concrete.

67. Glenarm Harbour (312155)

A curvilinear limestone-faced pier erected in the 1860s for the export of limestone and iron ore. Silting problems caused its supersedure by a small jetty near the whiting mill (at 314156; only traces remain). The pier head has now collapsed, although the harbour is still used by small pleasure boats. Quays, now ruinous, run along the riverside towards the bridge.

68. Limestone Quarries, Townparks, Glenarm (314154)

The prominent 'Town' and 'Mill' Quarries date to the early 1800s and have only recently ceased to be worked by the Eglinton Limestone Co. A mineral railway formerly ran down to the harbour, and also served the basalt quarry at the top of the hill. *Private.*

69. Mill Race to Whiting Mill, Glenarm (between 297098 and 315155)

The modern whiting mill, beside the road at the Mill Quarry east of Glenarm, is on the site of a mid-19th century water-powered mill. The water was brought along a four and a quarter mile long lade (millrace) which contours along the east side of the glen. This is one of the longest races in Ireland.

Prominent along it is a now-dry mill pond just above the village (313148). For half a mile beyond this, a footpath follows the infilled lade; it has been quarried away in the vicinity of the mill. The waterwheel was replaced by a steam engine around the turn of the century. Some water is still abstracted to a washing plant at the quarry. Visible in Glenarm Forest beside the signposted nature trail. *Forest Service.*

70. Corn Mill, Dickey's Town (316146)

On right bank of Altmore River downstream of road bridge, half a mile south-east of Glenarm. Ruinous shell set in deep gorge. Little is known of its history: it seemingly worked in the later 1800s, but was gutted by fire. Best seen from the bridge (erected after the mill ceased work). *Private.*

71. Pathfoot Incline, Minnis South (between 333136 and 339128)

This 1200yd long incline, with a 1-in-4 gradient, was one of the steepest sections of the old Larne-Glenarm Road. In the buildings at the foot of the hill, tracer horses were stabled to assist coaches up the hill.

72. Flax Scutch Mill, Cleggan (221102)

On right bank of Cleggan River near the Sheddings above Buckna. Later 19th century mill housing six sets of six-bladed handles (by Kane Brothers, Ballymena) and roller. Driven by a 14ft by 6ft overshot wheel (also by Kane). *Private.*

73. Flax Scutch Mill, Lough Connelly (194093)

On minor tributary of Braid River, one and a half miles north-west of Buckna. Later 19th century mill housing four sets of five-bladed handles and roller. Powered off a 14ft by 4ft 2in overshot wheel by David Christie, Ballymena. *Private.*

Waterwheel, Ballynacaird flax mill. (AS)

74. Wind Pump, Aghacully (206087)

In a farmyard one mile north of Buckna. A galvanized steel trestle supports the remains of a multi-vaned sail which pumped water to the nearby house in the 1930s. Several of the adjacent wooden outbuildings came from the Ammonia Works at Carnlough (55b). *Private.*

75. Flax Scutch Mill, Ballynacaird (209073)

On the Glen Burn, at the east end of Buckna. A two-storey rubble-stone building of later 19th century date, now gutted of machinery save the waterwheel, 18ft in diameter by 5ft wide. *Private.*

76. Flax Scutch Mill, Ballynacaird (219075)

On left bank of Glen Burn, half a mile east of Buckna. Early 19th century mill, now roofless, containing six sets of five-bladed handles and roller, powered off a high-breastshot 13ft by 5½ft wheel. *Private.*

77. Saw Mill and Electricity Station, Ballynacaird (222077)

One mile east of Buckna, just north of the Glenarm Road on the Glen Burn. A tin roofed building houses a circular saw driven off a 11½ft diameter by 4ft wide high-breastshot waterwheel by Kane of Ballymena. The wheel also powered an electricity generator, only the control panel of which now survives. A gutted water-powered flax mill adjoins. *Private.*

78. Flax Scutch Mill, Buckna (230076)

One mile east of Buckna village, on right bank of Glen Burn near Glen Bridge. Refurbished early 19th century mill, now gutted of machinery but still retaining impressive 20ft by 3ft wooden overshot waterwheel on gable. *Private.*

79. Antrim Coast Road (between Larne and Ballycastle)

Constructed in between 1832 and 1842 at a cost of some £37,000 under the direction of the

Scottish engineer William Bald. Its course hugs the shoreline as far as Cushendall, replacing a steeper inland route over the hills, then cuts inland over the moors to Ballycastle. In its time it was the biggest civil engineering project in the country, blasting through numerous small headlands, and contending with ground subject to frequent landslips. Whilst built for utilitarian purposes, the route also became a tourist attraction in its own right during the later 1800s. See numbered entries for site details.

One mile south of the Blackcave Tunnel (407042), opposite a lay-by, a plaque commemorates the road's construction: 'The Antrim Coast Road constructed 1832–1842 by the men of the Glynns under the direction of Wm. Bald, C.E., F.R.S.E'.

80. Coastguard Station, Ballygalley (373078)

A terrace of six brick cottages built sometime between the mid 1830s and '50s. Although refurbished, their original character is largely retained. On the shore to the east (374078) is a small boathouse with slipway on its seaward gable. *Private.*

81. Domestic Ice House, Carnfunnock (380066)

Formerly associated with Carnfunnock House, and now part of Larne Borough Council's Country Park. Dating to the earlier 19th century, this stone-lined chamber is 15ft high by 7ft in diameter, with a south-east facing entrance; no ante-passage.

82. Threshing Mill, Blackcave North (393054)

Near road junction at Drain's Bay, north of Blackcave Tunnel. Of mid-19th century date, and formerly associated with Port Pier Farm. High-breastshot waterwheel, 14ft in diameter by 2ft 4in wide on end gable of long two-storey building now devoid of machinery. *Private.*

83. Blackcave Tunnel, Blackcave North (399052)

Parabolic tunnel cut through basalt headland in 1830s as part of New Coast Road project.

84. Lighthouses, The Maidens (Hulin Rocks)

Five miles off Ballygalley Head. East and West Lights (at 457114, 450115 respectively) erected in 1828–29. The West Light was abandoned in 1903. The East Light has been automatic since the early 1980s.

85. Clay Pit, Ballycraigy (389048)

Small clay pit associated with Larne Brick Works, operational from 1880s to early 1900s. The quarter mile long tramway conveyed the clay-filled bogies to the brickworks (on the roadside at 391051), and can still be followed along the right bank of the stream. *Private.*

86. Pigeon House, Kilwaughter Castle Demesne (357015)

A square basalt tower in the farmyard behind the ruined castle. An internal spiral stairway ascends to a 4ft square chamber lit by four large openings with finely dressed sandstone surrounds. These allowed birds access to nesting shelves, now gone. *Private.*

87. Domestic Ice House, Kilwaughter Castle Demesne (361011)

Cut into a north-facing wooded slope in the castle grounds near the road. A vaulted passage, formerly with three sets of doors, leads into a well preserved circular brick-lined chamber. *Private.*

88. Kilwaughter Limestone Quarry, Rory's Glen (354009)

Extensive deep quarry operated by the Kilwaughter Chemical Co, and producing crushed limestone for fertilizer. Sizable kilns formerly stood nearby (354007). *Private.*

89. Water Reservoir, Killylane (J 290983)

A large earth/stone gravity dam at the head of Killylane Burn, erected by the Mid-Antrim Water Board and now operated by the Department of the Environment Water Service. Recreational walks and fishing.

Key to gazetteer maps.

Map 1: North. (Ordnance Survey, crown copyright reserved)

Map 2: Central. (Ordnance Survey, crown copyright reserved)

Map 3: South. (Ordnance Survey, crown copyright reserved)

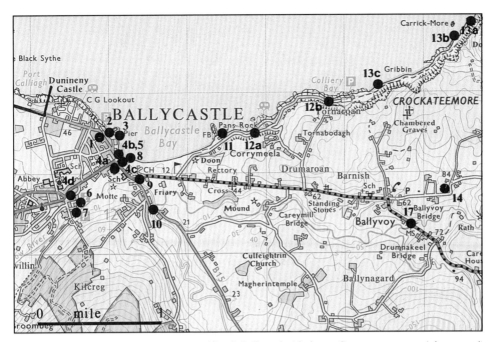

Map 4: Ballycastle. (Ordnance Survey, crown copyright reserved)

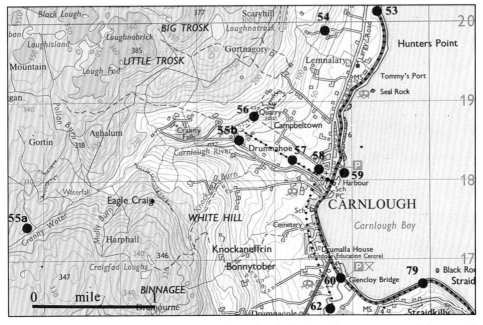

Map 5: Carnlough. (Ordnance Survey, crown copyright reserved)

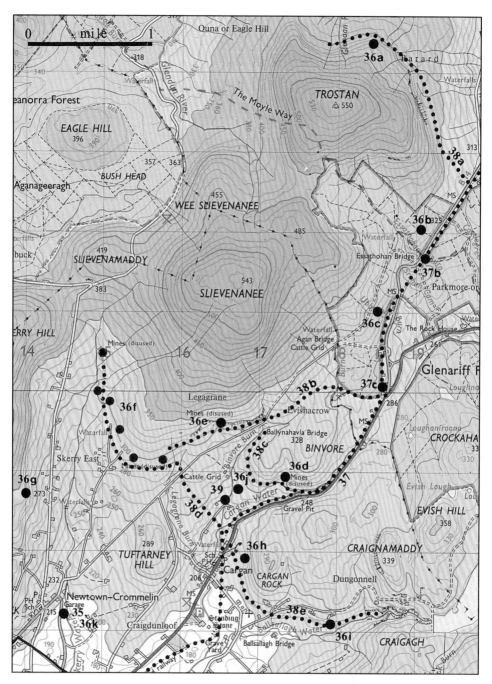

Map 6: Cargan. (Ordnance Survey, crown copyright reserved)

96

SITE INDEX

Sites are listed alphabetically by function, then by 6"/25" O.S. map number.

Each table shows: Column 1 – 6" map sheet; column 2 – 25" plan; column 3 – townland; column 4- National Grid co-ordinate (to nearest 100m and prefixed by 'D' unless otherwise stated); column 5 – present state (1= substantial remains; 2= some remains; 3= traces only; 4= site).

Aerial ropeways: see Ammonium Sulphate works, Ore mines

Ammonium Sulphate works

25	11	Carnlough South	275185	3
25	14	Aghalum	248174	2

Ammonium Sulphate works: aerial ropeway

25	11	Harp Hall	262179	3

Basalt quarries (selected)

05	13	Townparks (Ballycastle)	120415	1
30	01	Townparks (Glenarm)	320152	1

Basalt quarries: mineral railways

05	13	Townparks (Ballycastle)	121414	4
30	01	Townparks (Glenarm)	317154	4

Bauxite mines: see Ore mines

Bleach works

09	01	Townparks (Ballycastle)	120409	4

Breweries (see also Distilleries)

09	01	Townparks (Ballycastle)	120411	4

Brick works

09	01	Townparks (Ballycastle)	117406	4
09	02	Ballyreagh Lower	159408	4
35	11	Ballycraigy	391051	4

Brick works: clay pits

08	04	Townparks (Ballycastle)	114404	4
35	15	Ballycraigy	389048	1

Brick works: mineral railways

35	11	Ballycraigy	390050	2

Bridges: see Footbridges, Limestone quarries, Railways, Road bridges, Ore mines

Clay pit mineral railways: see Brick works

Clay pits: see Brick works

Coal mines (see also Lignite mines)

05	11	Knockbrack	188431	1
05	13	Broughanlea	138415	4
05	13	Broughanlea	139415	1
05	14	Drumaroan	141416	3
05	14	Tornaroan	144419	1
05	14	Tornaroan	148419	2
05	14	Tornaroan	151419	3
05	14	Tornaroan	153419	4
05	14	Ballyvoy	155420	2
05	14	Ballyvoy	158421	2
05	14	Ballyreagh Lower	160422	2
05	14	Ballyreagh Upper	164425	3
05	15	Craigfad	172420	3
05	16	Knockbrack	190427	1
09	01	Broughanlea	139412	4
09	02	Ballyreagh Lower	159408	1

Coal mines: related housing

05	16	Knockbrack	190430	1
09	01	Broughanlea	136409	1
09	02	Ballyreagh Lower	163407	1

Coastguard stations

05	13	Townparks (Ballycastle)	116420	1
05	13	Townparks (Ballycastle)	119414	1
05	13	Townparks (Ballycastle)	121414	4
10	01	East Torr	231403	1
10	01	East Torr	234405	1
10	10	Torcorr	249374	1
15	06	Cushendun	249327	4
15	14	Aghagheigh	247303	2
20	06	Waterford	244270	1
20	11	Ardclinis	271251	2
20	16	Galboly Lower	301240	2
20	16	Galboly Lower	302238	1
25	11	Carnlough North	287184	1
29	04	Parishagh	306157	1
30	01	Dickey's Town	323152	4
35	07	Ballygalley	373078	1
35	11	Drains	391055	1

Corn kilns (not associated with mills)

30	10	Lisnahay North	349116	4

Corn mills (see also Corn kilns)

08	04	Townparks (Ballycastle)	112404	1
08	07	Ballylig	089382	1
09	01	Broughanlea	129407	4
09	01	Carey Mill	140406	1
09	02	Carey Mill	143406	4
09	07	Ballypatrick	173398	1
09	07	Coolnagoppoge	176394	1
15	06	White House	241327	1
15	06	Ballindam	247333	4
15	13	Tavnaghdrissagh	218289	1
20	01	Cushendall	230279	4
20	01	Cushendall	236276	1
20	01	Killoughag	225277	4
24	09	Skerry East	145173	2
25	11	Harp Hall	283180	2
25	11	Carnlough South	286179	1
29	04	Dickey's Town	316146	2
29	08	Glenarm Demesne	301136	4
33	04	Breckagh	203093	1
33	04	Breckagh	204091	4
33	08	Ballyligpatrick	208074	4
34	03	Deer Park Farms	288090	1
34	05	Buckna	226076	2
35	02	Ballyruther	358095	3
35	07	Ballygalley	372071	1
39	14	Ballynashee	J 263973	3
40	06	Rory's Glen	354006	1

Cotton spinning mills

35	07	Ballygalley	373071	4

Creameries (see also Dairies)

34	03	Deer Park Farms	289096	1
35	10	Ballywillin	361054	1

Customs houses

09	01	Townparks (Ballycastle)	121412	4

Dairies (see also Creameries)

15	10	Lagflugh	250307	4
35	02	Ballyruther	357095	1

Distilleries (see also Breweries)

09	01	Townparks (Ballycastle)	120411	4
24	10	Legagrane	165186	2

Dovecots: see Pigeon houses

Electricity stations: water-powered

20	01	Cushendall	236276	1
33	08	Ballynacaird	222077	1
35	02	Ballyruther	358095	3

Electricity stations: wind-powered

18	16	Corkey South	104228	1

Fisheries (selected)

10	01	East Torr	233403	1

Flax scutching mills

08	08	Carneatly	098387	2
08	08	Drumawillin	103394	1
09	01	Broughanlea	129407	4
09	02	Drumnakeel	165404	1
09	07	Ballypatrick	173397	1
14	01	Cleggan	118344	4
15	05	Callisnagh	227319	1
15	06	White House	241327	1
15	06	Sleans	250326	4
15	09	Tromra	226307	4
15	13	Tavnaghdrissagh	218289	2
20	01	Lubitavish	222286	1
20	01	Killoughag	225277	4
28	16	Breckagh	203103	1
29	03	Galdanagh	283155	1
29	03	Aughareamlagh	272146	1
29	13	Ticloy	234109	4
29	13	Cleggan	221102	1
29	13	Tamybuck	226100	1

29	13	Tamybuck	224096	1
29	13	Tamybuck	228100	1
33	03	Lough Connelly	194093	1
33	04	Tamybuck	219091	4
33	08	Ballynacaird	222077	1
33	08	Ballynacaird	219075	2
33	08	Ballynacaird	209074	4
33	08	Ballynacaird	209073	1
34	05	Buckna	230076	1
34	12	Skeagh	312059	4
35	02	Ballyruther	357095	3

Flax spinning mills
20	01	Kilnadore	238277	4

Footbridges: over rivers
09	01	Townparks (Ballycastle)	122411	1
20	01	Ballymacdoe	238278	4
20	01	Knockeny	233275	1
20	02	Legg	242278	1
29	03	Ballyvaddy	283156	2

Fulling mills: see Wool fulling mills

Gas works
08	04	Townparks (Ballycastle)	114405	4
35	07	Ballygalley	382072	4

Glass works
09	01	Townparks (Ballycastle)	122411	3

Harbours
05	13	Townparks (Ballycastle)	121415	1
05	14	Tornaroan	151420	3
05	14	Tornaroan	154421	2
05	15	Cross	164427	3
09	01	Townparks (Ballycastle)	121413	2
10	01	East Torr	233403	1
15	06	Cushendun	250326	1
15	06	Sleans	253326	4
20	02	Ballymacdoe	244276	1
20	06	Red Bay	244260	1
20	10	Carrivemurphy	259250	3
20	11	Fallowvee	283254	2
20	16	Galboly Lower	302237	1
25	11	Carnlough North	288180	1
29	04	Townparks (Glenarm)	312155	1
29	04	Townparks (Glenarm)	314156	3
35	07	Ballygalley	374078	1

Hugh Boyd's sites, Townparks, Ballycastle
08	04	Holy Trinity Church	115407	1
09	01	Harbour	123410	2
09	01	Brewery	120411	4
09	01	Glass Works	122411	3
09	01	Bleach Works	120409	4
09	01	Manor House	121411	3
09	01	Soap Works	121411	1

Ice houses: commercial
09	01	Townparks (Ballycastle)	121413	1
10	01	East Torr	229402	1

Ice houses: domestic
09	01	Bonamargy	127406	4
20	16	Galboly Lower	301240	1
29	04	Glenarm Demesne	307147	2
35	11	Carnfunnock	380066	1
40	06	Demesne (Kilwaughter)	361011	1

Inclined planes: see Ore mines

Iron ore mines: see Ore mines

Iron ore smelter: see Ore mines

Kelp stores
25	11	Carnlough North	288181	1

Kilns: see Corn kilns, Lime kilns

Lighthouses
30A		Hulin Rocks	457114	1
30A		Hulin Rocks	450115	1

Lignite mines (see also Coal mines)
29	08	Libbert West	311136	4

Lime kilns (selected)
05	15	Bighouse	189417	1
05	16	Torglass	197422	1
08	04	Townparks (Ballycastle)	110403	3
08	16	Stroan	108353	4
09	08	Ballyvennaght	211388	4
09	11	Glenmakerran	176374	4
09	11	Ballypatrick	188375	4
10	01	West Torr	216406	2
14	01	Cleggan	118344	4
19	03	Eshery	180278	4
25	07	Lemnalary	286198	1
25	11	Carnlough North	282183	4

25	11	Carnlough North	286181	1
29	04	Demesne Upper (Glenarm)	304150	1
35	06	Corkermain	351074	4
35	06	Ballygalley	360072	1
35	07	Ballygalley	380075	1
35	10	Ballytober	362051	4
35	14	Killyglen	366040	1
35	15	Dromain	372049	4
35	15	Ballycraigy	382044	1
35	15	Ballycraigy	386045	4
40	06	Rory's Glen	351011	1
40	06	Rory's Glen	351011	4
40	06	Rory's Glen	352008	4
40	06	Rory's Glen	354007	4

Limestone quarries (selected; see also Lime kilns, Whiting mills)

05	13	Townparks (Ballycastle)	118418	1
08	12	Toberbilly	101365	1
20	05	Knockans South	228258	1
25	11	Gortin	276187	1
25	11	Creggan	280190	1
29	03	Ballyvaddy	283153	1
29	04	Demesne Upper (Glenarm)	304150	1
29	04	Townparks (Glenarm)	314154	1
29	04	Parishagh	304160	1
29	04	Townparks (Glenarm)	315154	1
40	06	Rory's Glen	354009	1

Limestone quarries: mineral railways

05	13	Townparks (Ballycastle)	120416	4
25	11	Carnlough South	282183	1
25	11	Bay	286167	1
29	04	Townparks (Glenarm)	316154	4

Bridges: over Rivers

25	11	Carnlough North	285180	3
25	15	Bay	287165	3
29	03	Bay	284156	1

Bridges: over Roads

25	11	Carnlough North	287180	1
25	11	Carnlough North	287180	1

Limestone quarries: related housing

29	03	Ballyvaddy	283155	1

Marconi memorial stone

05	13	Townparks (Ballycastle)	120415	1

Mills: see Corn, Flax, Saw, Threshing, Whiting, Wool fulling mills

Mineral railways: see Basalt quarries, Brick works, Limestone quarries, Ore mines

Mines: see Coal, Lignite, Ore mines

Ore mines: bauxite and/or iron ore (mine names in brackets; grids approximate)

05	15	Cross (Carrickmore)		167426	3
19	11	Barard (Trostan)		190240	1
20	11	Ardclinis		273240	1
20	11	Carrivemurphy		267240	1
20	11	Galboly Upper		283249	1
20	14	Bay		254237	4
24	03	Parkmore (Essathohan)		193223	1
24	05	Skerry East		140201	2
24	06	Skerry East (Crommelin)		152195	1
24	06	Legagrane (Glenravel)		166196	1
24	07	Evishacrow (B'nahavla)		171196	1
24	07	Parkmore (Parkmore)		186210	1
24	08	Cloghcor (Glenariff)		215196	2
24	09	Skerry East		140186	1
24	10	Cargan (Cargan)		168179	2
24	10	Tuftarney (Tuftarney)		159178	3
24	11	Evishacrow (Evishacrow)		173189	1
24	15	Dungonnell		182171	1
25	10	Harphall		257177	3
25	11	Aghalum (Gortin)		265190	4
25	15	Drumourne		270173	3
28	02	Evishnablay (Mt Cashel)		165152	2
28	02	Crooknahaya		160148	2
29	02	Unshinagh South		266155	4
29	03	Aughareamlagh		271145	3
29	03	Ballyvaddy		284146	3
29	08	Glore		295134	3
29	08	Glebe		294131	3
29	12	Longfield		295128	3
29	08	Libbert West		312136	4
40	05	Moordyke		333002	4
40	09	Boydstown	J	333986	4
40	09	Hightown	J	334988	4

Ore mines: aerial ropeways

20		Legagrane etc.	200230	4

Ore mines: inclined planes

20	11	Ardclinis	270246	1
24	10	Legagrane	164186	1

Ore mines: mineral railways

– Ballymena/ Retreat Line

Stations

19	12	Retreat	204241	3
24	07	Parkmore	186201	1
24	10	Cargan	165080	2

Bridges: over roads

19	12	Retreat	202239	3
24	03	Parkmore	188212	2
24	04	Parkmore	194222	2

Bridges: over rivers

24	03	Parkmore	189214	2
24	03	Parkmore	191217	1
24	04	Parkmore	194221	2
24	07	Cargan	182193	3
24	07	Cargan	183193	4
24	11	Cargan	179188	1
24	11	Cargan	179189	2
24	14	Craigdunloof	165170	1

Bridges: under roads

19	16	Retreat	199229	2
19	16	Retreat	195223	2
24	03	Parkmore	186207	2
24	03	Parkmore	188211	1
24	03	Parkmore	194221	2
24	03	Parkmore	192218	2
24	03	Parkmore	190216	2
24	07	Parkmore	185197	1
24	10	Cargan	165179	4
24	11	Cargan	171186	1

– Cargan siding

24	10	Cargan	175177	2

– Crommelin siding

24	06	Legagrane	157192	2

Bridges: over rivers

24	10	Legagrane	165183	2
24	06	Skerry East	150203	1

Locomotive Shed?

24	06	Legagrane	159192	3

– Evishacrow siding

24	07	Evishacrow	173191	1

Bridges: over rivers

24	11	Evishacrow	175187	1

– Parkmore siding

24	06	Legagrane	173196	1

Bridges: over rivers

24	06	Legagrane	164195	2

24	07	Legagrane	171197	1
24	07	Evishacrow	180201	2

– Trostan siding

19	11	Barard	187233	2

– Glenariff line

20		Cloghcor	235221	1

Bridges: over roads

20	10	Carrivemurphy	256248	2

Bridges: over rivers

20	13	Greenaghan	236227	2

Locomotive sheds

20	10	Carrivemurphy	255247	2

Ore mines: related housing

09	02	Ballyreagh Lower	163407	1
20	10	Carrivemurphy	254247	1
24	07	Parkmore	186205	4
24	10	Evishacrow	167188	2
24	10	Cargan	165178	1
24	14	Craigdunloof	163171	1

Ore mine smelter

24	09	Skerry East	145173	1

Passenger railways: see Railways

Piers: see harbours

Pigeon houses

25	07	Lemnalary	284193	3
40	06	Demesne (Kilwaughter)	357015	1

Quarries: see Basalt, Limestone, Sandstone quarries

Quays: see harbours

Railways (for mineral railways, see Brick works, Limestone quarries, Ore mines)

– Ballymoney/Ballycastle line

Stations

08	04	Townparks (Ballycastle)	116407	1
08	11	Cape Castle	087367	3

Bridges: over rivers

09	01	Townparks (Ballycastle)	116406	1

Bridges: over roads

08	08	Broommore	099386	2
08	08	Broommore	099386	3

Tunnels

08	11	Cape Castle	087367	1

– Ballymena/Parkmore line

Stations

24	07	Parkmore	186201	1
24	10	Cargan	165080	2

Bridges: see Ore mines

Reservoirs: see Water reservoirs

Road bridges: over rivers (selected; for railway-related road bridges, see Limestone quarries, Ore mines, Railways)

09	01	Bonamargy	126406	1
09	01	Townparks (Ballycastle)	123410	1
09	01	Townparks (Ballycastle)	125410	4
09	01	Townparks (Ballycastle)	123409	1
09	02	Acravally	141406	1
09	02	Drumnakeel	161399	1
09	02	Ballyvoy	158403	1
09	03	Drumadoon	175400	4
09	03	Ballypatrick	173398	1
09	08	Ballyvennaght	201386	1
09	11	Ballypatrick	188379	1
09	12	Ballypatrick	195369	1
09	13	Clare Mountain	141357	1
09	14	Greenan	144353	1
09	16	Ballyvennaght	207359	1
09	16	Ballypatrick	196366	1
09	16	Ballypatrick	199362	1
10	05	Ballinloughan	230391	1
13	16	Magherahoney	101298	1
13	16	Magherahoney	105299	1
14	01	Breen	118342	4
14	08	Clegnagh	216321	1
14	15	Beaghs	174292	1
14	15	Beaghs	179297	1
15	01	Grange Inispollan Mt.	222339	1
15	02	Tornamoney	252347	1
15	05	Knocknacarry	240326	1
15	05	Ballure	222322	1
15	05	Knocknacrow	225321	1
15	05	Clady	221329	1
15	06	Cushendun	249326	1
15	09	Mullarts	229310	1
18	12	Ballyraddin	105249	1
19	02	Beaghs	162275	1
19	03	Beaghs	168282	1
19	10	Beaghs	152243	1
19	16	Retreat	199233	4
20	01	Cloghs	229280	1
20	01	Cushendall	238276	1
20	01	Murroo	221271	2
20	09	Foriff	239255	1
20	11	Ardclinis	270250	1
20	11	Ardclinis	270250	1
20	13	Doory	225233	1
24	03	Parkmore	191217	1
24	07	Evishacrow	180206	1
24	07	Evishacrow	172196	1
24	09	Skerry East	146176	1
24	10	Tuftarney	158188	1
24	10	Cargan	163178	1
24	11	Cargan	170186	1
24	14	Cargan	167169	1
25	01	Doory	223220	1
25	01	Baraghilly	224214	1
25	01	Toberwine	219211	1
25	04	Burnside	293211	1
25	04	Ballyvellgan	293219	1
25	04	Newtown	297217	1
25	04	Burnside	296210	1
25	08	Highlandtown	293201	1
25	11	Carnlough South	286179	1
25	15	Bay	288168	1
28	11	Clonetrace	173113	1
28	16	Longmore	206100	1
29	03	Aughareamlagh	273146	1
29	04	Cloney	311153	1
29	04	Townparks (Glenarm)	310151	1
29	08	Glenarm Demesne	302135	1
29	12	Great Deer Park	300123	1
29	13	Killycarn	224101	1
29	13	Tamybuck	223099	1
29	14	Antynanum	252110	1
29	14	Tamybuck	250109	1
29	16	Great Deer Park	303111	1
29	16	Great Deer Park	300100	1
29	16	Great Deer Park	300101	1
33	04	Breckagh	204093	1
33	04	Aghacully	211083	1
33	07	Ballyligpatrick	197065	1
33	08	Ballynacaird	210075	1
33	11	Creevamoy	195060	1
34	03	Deer Park Farms	289091	1
34	04	Deer Park Farms	317097	1
34	04	Deer Park Farms	318093	1
34	04	Aughaboy	312082	1
34	05	Buckna	231075	1
34	07	Drumcrow	274079	1
34	08	Linford	319074	1
34	08	Aughaboy	310071	1
34	08	Aughaboy	299066	1

34	10	Shillanavogy	249048	1
34	12	Mullaghsandall	320054	1
34	12	Skeagh	312059	1
35	05	Dunteige	320079	1
35	07	Ballygalley	372078	1
35	11	Carnfunnock	376064	1
35	11	Ballywillin	371060	1
35	11	Drains	391052	1
35	15	Drains	382046	1
35	15	Dromain	378041	1
39	10	Glenhead	J 261996	1
39	10	Glenbridge	J 262994	1
39	10	Ballynashee	J 263987	1
39	11	Braetown	J 277998	1
39	11	Braetown	J 274996	1
39	12	Skerrywhirry	299000	1
39	12	Hightown	J 314997	1
40	02	Killyglen	353032	1
40	03	Ballyhampton	372020	1

Road cuttings

20	12	Galboly Lower	300243	1

Road inclines

30	05	Minnis South	336132	1
20	16	Galboly Lower	302244	1

Road tunnels

20	06	Red Bay	244261	1
35	12	Blackcave North	399052	1

Salt works

05	13	Broughanlea	135415	1

Sandstone quarries (selected)

05	13	Broughanlea	138415	1

Saw mills

08	04	Townparks (Ballycastle)	115407	1
08	04	Townparks (Ballycastle)	116406	4
20	01	Cushendall	236276	1
33	08	Ballynacaird	222077	1

Scutch mills: see Flax mills

Seaweed: see Kelp stores

Soap works

09	01	Townparks (Ballycastle)	121411	1

Spinning mills: see Cotton, Flax mills

Sulphate of Ammonia works: see Ammonium Sulphate works

Tanneries (selected)

09	01	Townparks (Ballycastle)	121411	4
15	05	Cloney	239321	4

Threshing mills

08	08	Drumawillin	103394	1
30	01	Dickey's Town	319149	4
34	03	Deer Park Farms	288090	1
35	07	Ballygalley	382072	4
35	11	Blackcave North	393054	1
35	11	Ballytober	372055	4

Tramways: see Brick works, Limestone quarries, Ore mines

Tuck mills: see Wool fulling mills

Water pumps: water-powered

20	12	Galboly Lower	301244	1

Water pumps: wind-powered

25	11	Carnlough South	275185	3
33	04	Aghacully	206087	1

Water reservoirs

05	13	Townparks (Ballycastle)	119413	4
08	04	Townparks (Ballycastle)	110408	4
19	13	Altnahinch	124234	1
20	01	Cushendall	237276	1
24	16	Dungonnell	196172	1
28	07	Quolie	181131	1
28	07	Quolie	188137	1
35	15	Ballymullock	377037	1
35	15	Ballyboley	378035	1
39	15	Killylane	J 290983	1

Water reservoirs: treatment works

18	12	Corkey South	117236	1
39	11	Ballyalbanagh	J 281985	1

Whiting mills

25	11	Carnlough South	285180	4
29	04	Townparks (Glenarm)	315155	1

Wool fulling mills

08	04	Drumawillin	106397	4
14	16	Lubitavish	213289	3
20	10	Bay	251244	4

Printed in the United Kingdom for HMSO
Dd. 8279456, C25, 10/91, 3549